IMAGES
of America

GODFREY

IMAGES
of America

GODFREY

Jill Moon

ARCADIA
PUBLISHING

Published by Arcadia Publishing
Charleston, South Carolina

Printed in the United States of America

Library of Congress Control Number: 2013935140

For all general information, please contact Arcadia Publishing:
Telephone 843-853-2070
Fax 843-853-0044
E-mail sales@arcadiapublishing.com
For customer service and orders:
Toll-Free 1-888-313-2665

Visit us on the Internet at www.arcadiapublishing.com

To family, on which every community and history is based.

CONTENTS

ACKNOWLEDGMENTS

I accepted the challenge of this project after considering the friendships and connections I had made in the village of Godfrey over nearly a decade of covering the growing community for the *Telegraph*, a daily newspaper based in neighboring Alton, Illinois.

I approached this book as a way to show cultural themes among the people of the area from its founding through modern times. Instead of a chronological succession, I wanted to show common customs and practices shared by the region's settlers who relied on the soil under their feet, available resources, and the desire to thrive. They created a community through their livelihoods, agriculture, socialization, innovation, industrialism, conservation, and development.

I first must thank a friend I made through the course of my career in 2006, immediately after becoming a writer for the *Telegraph*. Besides immediately thinking about Capt. Benjamin Godfrey—Godfrey's founder and the establisher of the first institute for the higher education of women on the edge of the western frontier—I thought of Erwin A. Thompson and his massive knowledge of area history. Through his own photograph collection and writings from more than 97 years, Erwin's story tells the story of Godfrey's everyday people. From the time that this book project started through its final approval to publication, we spent numerous hours together while he told me this history, starting for him at the age of nine months old on his grandfather E.A. Riehl's homestead, where Erwin has lived for his entire life. Unless otherwise noted, all images in chapters three, four, five, and six are courtesy of Erwin A. Thompson.

Erwin's daughter Janet Riehl became a conduit of our energy through generations of time, helping me through the process of connecting eras to create this book. Erwin's story is that of Godfrey—seeing farmland become subdivisions, riverbanks become highways, and wagon trails become paved roads.

I also would like to thank Monticello College Foundation's executive director Linda Nevlin, an alumna of Monticello College (whose campus became that of Lewis and Clark Community College in 1970–1971), and Lewis and Clark Community College president Dr. Dale Chapman. Unless otherwise noted, images in chapters one, two, and three are courtesy of the Lewis and Clark Community College and the Monticello College Foundation.

Thanks also go to the Great Rivers Land Trust's executive director Alley Ringhausen, who oversees the institution that has saved in perpetuity one-of-a-kind limestone bluff tops from becoming parking lots and cliff-perched resorts; the staff at The Nature Institute, especially its director or stewardship, Tim Schofield; Godfrey historian Judy Hoffman; the Droste family, especially George Droste; the Koeller family, especially Steve Koeller; longtime Godfrey resident Verna Hoffman; Godfrey mayor Mike McCormick; and former Godfrey mayor Mike Campion.

In regards to the technical aspect of this book, I would like to thank the *Telegraph*'s supervising copy-desk editor Missy Wuellner, without whom these photographs would never have crossed into the digital world. I would also like to thank the *Telegraph*'s assistant city editor, Stephen Whitworth, who first edited the pages of this book.

INTRODUCTION

Although the "young" village of Godfrey only became incorporated in 1991, its residential, agricultural, and intellectual growth began in the early 19th century. It became a full-fledged town by 1838, when transplants, mostly from the eastern United States, began referring to the area as Monticello once the architectural landmark Monticello Female Seminary was established that same year. Monticello's buildings and artwork remain well-preserved today as the campus of Lewis and Clark Community College, just one example of Godfrey's attractions for visitors, homeowners, and business people—preservation based on the ancestral values of its early people.

A sea captain, Benjamin Godfrey, originally born in Cape Cod, Massachusetts, came to the area in 1832, presumably seeking financial opportunities among the rolling hills of Southwest Illinois, which reminded him of home. He founded Monticello Female Seminary, the first Midwestern institution for the higher education of women, and built the railroads that connected the neighboring town of Alton, in Madison County to the northern towns of Springfield (Illinois's state capital) and Joliet, located 40 miles southwest of Chicago. Eventually, this rail system connected to Grafton, approximately 18 miles from Godfrey to the west in Jersey County, and to St. Louis, Missouri, located approximately 40 miles south across the Mississippi River from Alton-Godfrey. The area became named for Godfrey, the formerly rough-and-tumble seaman, who became a pious businessman, reformer, innovator, and philanthropic leader in the region.

Prior to Godfrey bringing and attracting a more genteel and humanitarian population to the area, Godfrey's first recorded settlers came from Kentucky in 1817. Rev. Jacob Lurton and his wife, Sarah (Tuley), brought several family members and half a dozen slaves to the land, which ultimately became a hotbed of abolitionism and a known shelter for runaway slaves and free African Americans. The Lurtons and their surrounding neighbors openly disliked Yankees; these differences ultimately caused the Lurtons and like-minded settlers to leave the area.

Along with Captain Godfrey in his day, other Easterners began to populate the land that became Godfrey. Farmers Nathan and Latty Scarritt were among the first to settle and thus called a large portion of the land Scarritt's Prairie. The Scarritts, who were deeply religious and lived heartily off the land (which they worked without slaves), became surrounded by more people from the East Coast who held similar beliefs and values. Godfrey, at the time, represented a contrasting culture to that of its neighbor, the town of Alton, which was anti-abolitionist and a rough riverfront town spotted with taverns, boat docks, labor-intensive shops, and warehouses; East Coast businessmen developed the Alton riverfront.

These businessmen saw the economic benefit of a riverfront business district. The Alton population saw the area that became Godfrey as a primary source for natural resources and agricultural goods, which the village had provided throughout the years by generations of early prominent families such as the Riehls, Stankas, Locks, Drostes, Koellers and Stiritzes, to name a few.

Godfrey's Rocky Fork area is home to a hand-built, white clapboard church that replaced the original, similarly built church destroyed twice in the late 20th century due to vandalism; the

rebuilt church still stands and holds services to this day. The Rocky Fork area and neighboring Warren Levis Boy Scout Camp area are verified as Underground Railroad sites through the National Park Service's program Network for Freedom.

Captain Godfrey became a partner in a freight-forwarding business called Godfrey, Gillman & Co., located in Alton, where he grew his riches. He built the first church in Alton, a mansion in Godfrey, which still stands and serves as a monument to Godfrey's founding father, and Monticello Female Seminary, the first women's college west of the Allegheny Mountains.

The fledgling village of Godfrey continued to grow throughout the mid-19th century, attracting individuals who were like-minded to those who first settled there. Some of Godfrey's first long-standing families began to move to the area, including the Riehls, who cultivated innovative horticultural ideas that led to products sold all over the United States; the Locks, who formerly owned the land that became Lockhaven Country Club; the Stiritzes, who planted vineyards and had one of the first establishments that served wine in Godfrey; the Whites, who still have a nursery in Godfrey; and the Normans, who started a successful tugboat company and did commercial mussel diving.

Generations of these families saw the most change in Godfrey between the late 1800s and late 1960s, when they saw the extinction of steamboat traffic and witnessed miles of the Mississippi River's banks and railroad tracks become the Great River Road, which is Illinois Route 100 and a National Scenic Byway. The longest stretch of the Great River Road is located in Godfrey. These families saw agricultural fields become business districts along paved roads such as Homer M. Adams Parkway and Godfrey Road, which used to be dirt roads. They have seen the rise of Godfrey as a bedroom community. Now, Godfrey is the second-largest community area-wise, at 37 square miles, in the state of Illinois.

With the addition of a major highway extension—Illinois 255—and a business corridor, the third and current Godfrey administration sought tools for economic growth, such as creating a tax increment financing district and a business district, both established in 2012, which became a first in the village's history. Only three mayors have served Godfrey to this day.

The consistent desire for and effort towards preservation and conservation shows that the people of Godfrey want to maintain its history as well as attract visitors to its vast green spaces and untouched-by-development bluff tops.

The Godfrey community boasts eco-tourism opportunities and admirable conservation projects with the 300-acre John T. Olin Nature Preserve on the limestone bluffs overlooking the Mississippi River, the Kemp and Cora Hutchinson Bird Sanctuary, the Great Rivers Land Trust, The Nature Institute, and the Oblates Community Supported Garden, which is open for the public so that they may enjoy its organic agriculture.

One

Capt. Benjamin Godfrey and Other Innovators

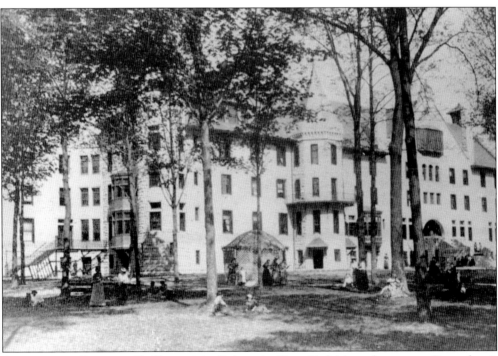

A sea captain, Benjamin Godfrey, originally born in Cape Cod, Massachusetts, on December 4, 1794, came to the area in 1832, presumably seeking financial opportunities among the rolling hills of southwest Illinois, which reminded him of home. He founded Monticello Female Seminary in 1838, the first Midwestern US institution for the higher education of women. The area subsequently became named for Godfrey the formerly rough-and-tumble seaman who became a pious businessman, reformer, innovator, and philanthropic leader in the region.

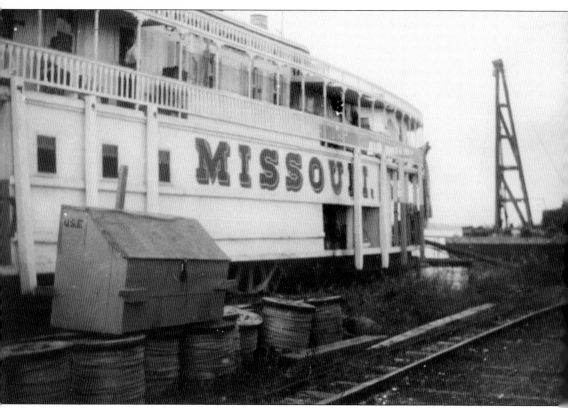

Capt. Benjamin Godfrey built the railroads that connected the neighboring town of Alton in Madison County to the northern towns of Springfield (Illinois's state capital) and Joliet, 40 miles southwest of Chicago. Eventually, the rail system connected to Grafton, approximately 18 miles to the west in neighboring Jersey County (in which a portion of Godfrey is also located), as well as to St. Louis, Missouri, located 40 miles south across the Mississippi River from Alton-Godfrey. Captain Godfrey became a partner in a freight-forwarding business, Godfrey, Gillman & Co., located in Alton, where he grew his riches. (Courtesy of Erwin A. Thompson.)

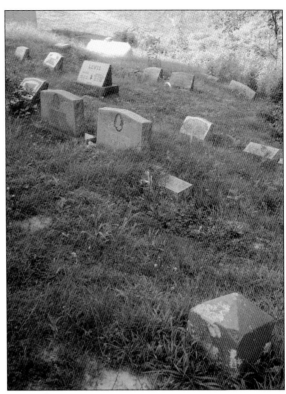

In Godfrey's Rocky Fork area, the church pictured below replaced the last white, clapboard, hand-built church that was destroyed twice due to vandalism; this church still stands and holds services to this day. The Rocky Fork area and neighboring Warren Levis Boy Scout Camp area are verified as Underground Railroad sites through the National Park Service's program Network for Freedom. The cemetery pictured is located adjacent to the church grounds and includes many original settlers from the Rocky Fork area. (Both, courtesy of the author.)

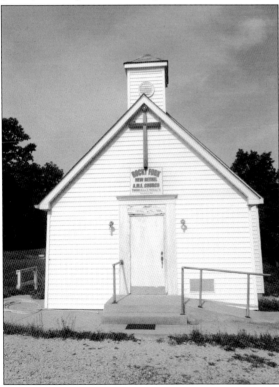

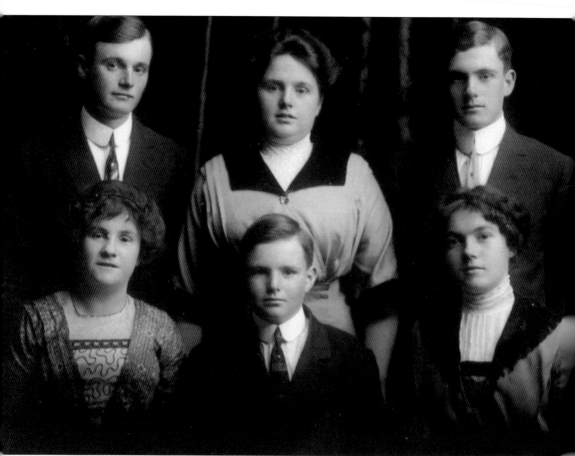

The fledgling village of Godfrey continued to grow, attracting individuals who were like-minded to those who first settled there. Godfrey Township is located mostly in Madison County, with a small portion of the township located in neighboring Jersey County. Some of Godfrey's early families that moved to the area include the Riehls, who cultivated innovative horticultural ideas that led to products sold all over the United States; the Locks, who owned a farm adjacent to the Riehl property; the Stiritzes, who planted vineyards and had one of the first Godfrey establishments that served wine; the Whites, who still have a nursery in Godfrey; and the Normans, who started a successful tugboat company and did mussel diving. Lock family patriarch Charles Edward Lock signed the right-of-way agreement on July 15, 1887, for the Chicago/St. Louis, Alton & Springfield railroad, known to locals as the Springfield Line because it went to Springfield, Illinois. Some of the Lock children (pictured here) eventually sold the family acreage to a development company to build a country club that first became the private, members-only Lockhaven Country Club and, then in 2013, became the public play Lockhaven Golf Club. (Courtesy of Erwin A. Thompson.)

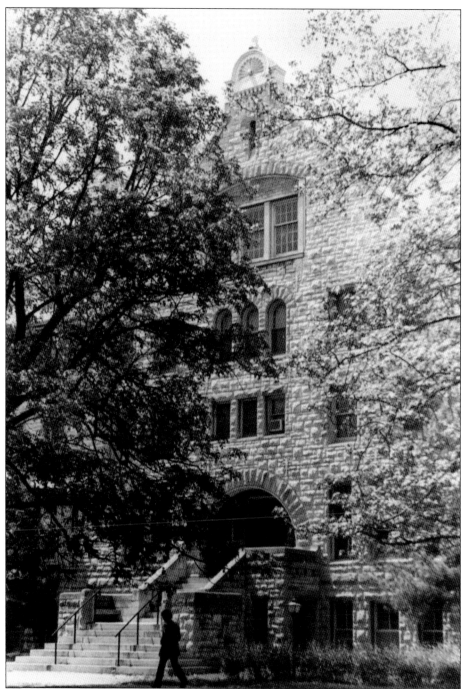

Capt. Benjamin Godfrey founded Monticello Female Seminary, which is located in the present-day heart of Godfrey on Godfrey Road, also known as US 67. The school was not only one of the first of its kind for women in the West, but it was also one of Illinois's oldest institutions for higher learning. Monticello's buildings remain well-preserved today as the campus of Lewis and Clark Community College—an example of Godfrey's attractions for visitors, homeowners, and business people: preservation based on the ancestral values of its early people.

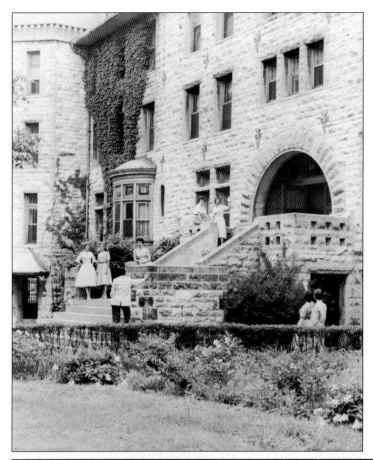

In the 1960s, Monticello Female Seminary became a junior college but remained an all-female school known as Monticello College. It ceased operating in 1970 when Lewis and Clark Community College purchased the entire campus and its buildings. As a junior college, it held much the same values as when Capt. Benjamin Godfrey founded the original Monticello Female Seminary.

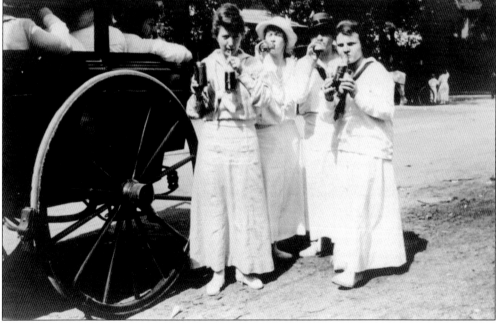

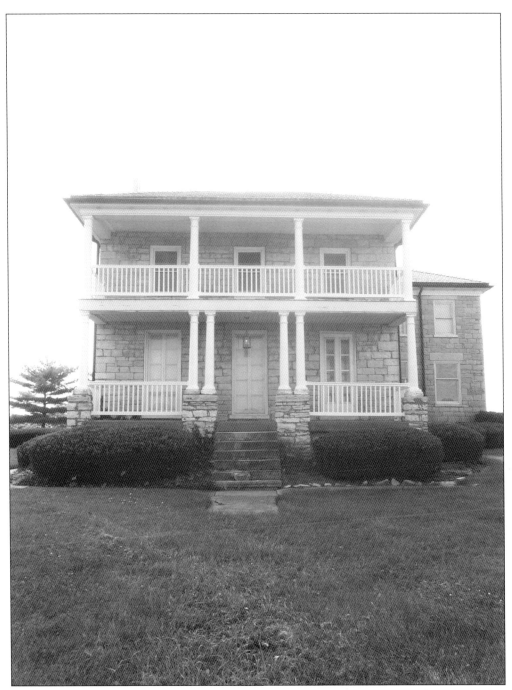

Capt. Benjamin Godfrey built a limestone mansion that was completed in 1833 by Calvin Riley, according to a memorandum about the Godfrey mansion written by Herbert E. Hewitt of Peoria, Illinois, for the Historic American Buildings Survey. In 1834, Godfrey settled into the mansion located a short distance away from present-day Godfrey Road (US 67) and present-day Airport Road. Monticello Female Seminary was located on the same road, which at the time was constructed of wooden planks. Godfrey lived in the house until his death in 1862. (Courtesy of the author.)

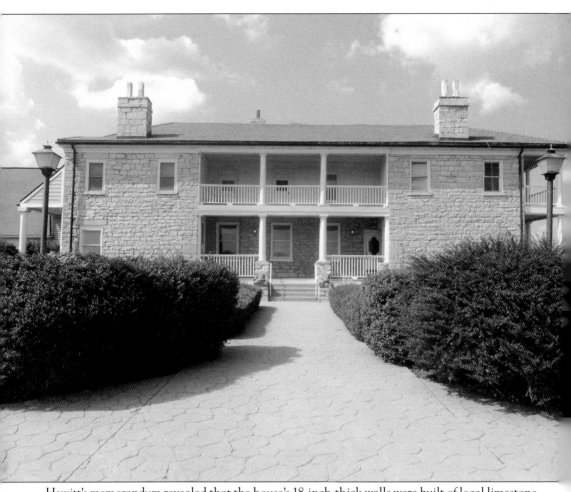

Hewitt's memorandum revealed that the house's 18-inch-thick walls were built of local limestone, that the structural lumber is of oak and other native trees, and that the interior millwork appeared to have been imported from New Orleans or Massachusetts. Hewitt determined the exterior millwork to be that of unskilled craftsmen, both in design and execution, while the interiors seemed of higher-quality craftsmanship. The first floor's wood mantles, as well as some of the interior woodwork, show the Greek Revival style that was fashionable during the 1830s and 1840s. (Courtesy of the author.)

When Lewis and Clark Community College acquired the Monticello Female Seminary campus in the early 1970s, the Godfrey mansion still had private owners. Eventually, the college acquired the property to complete its legacy of preserving Benjamin Godfrey's history through architectural structures. The college now has ownership of the former Monticello Female Seminary campus and buildings, the Godfrey Memorial Chapel, and the Godfrey Mansion, all located on Godfrey Road. The mansion's exterior remains largely unchanged since its completion in 1833, creating an interesting and telling juxtaposition of the village of Godfrey's predilection for both preservation and progress, with the new highway extension Illinois 255, completed in 2013, running through Godfrey and past the mansion on Godfrey Road, as seen in the background to the right in this recent picture. (Courtesy of the author.)

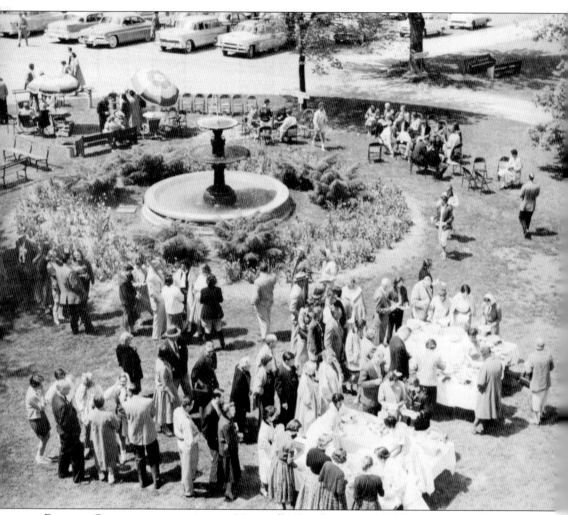

Fountain Court was a centerpiece on Monticello Female Seminary's 300-acre campus. Today, the fountain is surrounded by Monticello's original structures and Lewis and Clark Community College's later-built structures. Plants comprising the Missouri Botanical Signature Garden enhance the campus for social events such as wedding receptions and other outside uses, for both the college and public rentals.

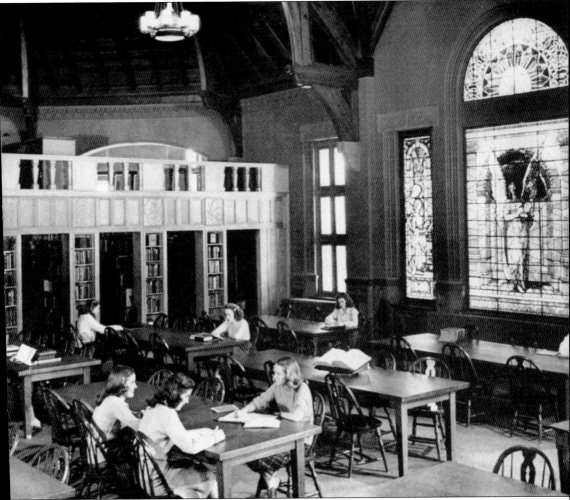

The large, stained-glass piece in Reid Memorial Library is known as the Praise Angel Window. This installation, pictured at the far right, and the majority of the 75 stained- and art-glass features on campus, were added to the historic main campus complex when it was built in 1889–1890, following a devastating fire that destroyed the original Monticello building in 1888. The stained- and art-glass features were restored in 2012 by Illinois's Jacksonville Art Glass.

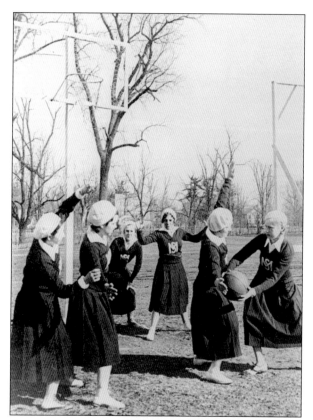

Benjamin Godfrey was a mentor to Monticello Female Seminary's second principal and first female administrative officer, Philena Fobes, who oversaw the school from 1843 to 1865. As a like-minded counterpart to Godfrey and a strong advocate for women's physical fitness, Fobes introduced field games and sports activities to campus life. The image below shows the popular May Day activity of an earlier era.

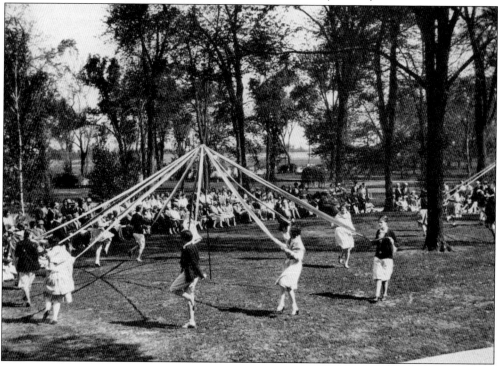

Two

LANDMARK
FOR EDUCATION

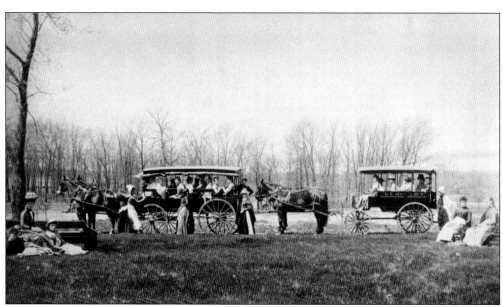

Monticello Female Seminary, founded by Capt. Benjamin Godfrey and named after the Virginia estate of Thomas Jefferson, opened its first year with instructors and 11 to 16 students in residence on April 11, 1838. Monticello saw its first graduating class in 1841. This image shows a means by which students traveled before Captain Godfrey founded the area's railroads.

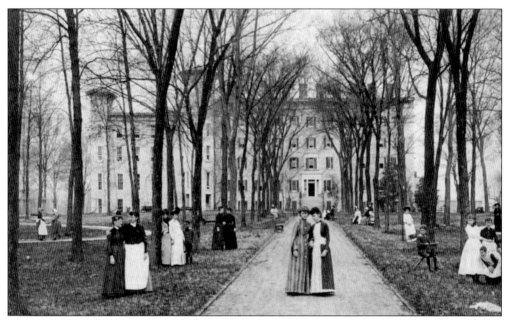

Monticello Female Seminary stood as a symbol of genteel civilization in the developing Midwest. The liberal arts school was 40 miles north of St. Louis, Missouri, and was eventually included on the Chicago, Alton & St. Louis Railway route. A rolling prairie studded with trees surrounded Monticello, eventually located a half-mile from a railroad station once Capt. Benjamin Godfrey ushered the age of rail travel into the region. A long, noble brick avenue led to the original Monticello's magnificent entrance. The image above shows a view looking up the avenue toward the entrance; the image below shows the view in the opposite direction, facing present-day Godfrey Road (US 67).

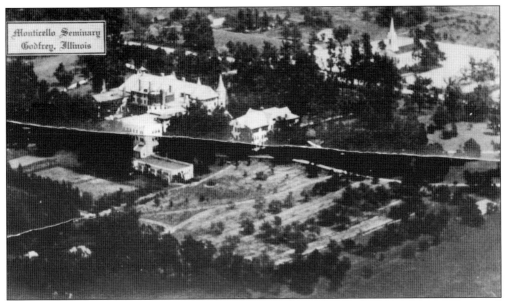

The image above shows an overview of the Monticello Female Seminary campus. The original seminary building was modeled after Princeton College's Nassau Hall. Monticello's campus, during third principal Harriet Newell Haskell's tenure, came to encompass its entire 300 acres; the original campus was 48 acres. Haskell became the longest-serving principal for the school, as she was principal from 1867 until her death in 1907. Haskell is pictured below, at the far left, with students of Monticello Female Seminary in the 1880s.

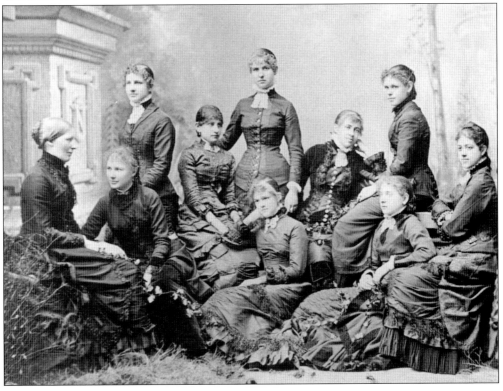

Monticello's first female principal, Philena Fobes, who was the school's second president from 1843 to 1865, introduced gymnasium work to campus life. This carried through to later times, as shown by the student pictured at left wearing a sports team sweater. The same student is pictured below with fellow Monticello schoolmates.

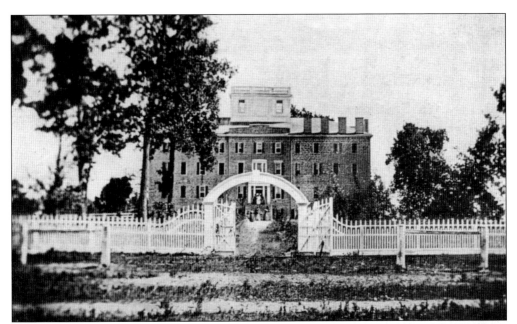

Shown above is the original structure of Monticello Female Seminary (1838–1888), which was one of the country's oldest colleges for women and the first of its kind in the Midwest.

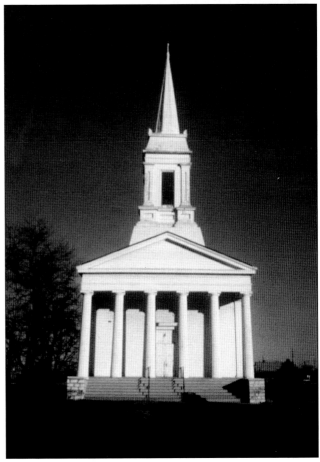

This simple New England chapel, built in 1854, served both the community and Monticello students at various times. Later renamed the Godfrey Memorial Chapel, it was built in the Greek Revival tradition and was originally located across US 67 from Monticello campus proper. The chapel was purchased by Lewis and Clark Community College in 1970, when it purchased the entire Monticello College campus. In 1991, Lewis and Clark Community College had the chapel moved from across the highway to its present location on the campus's south side.

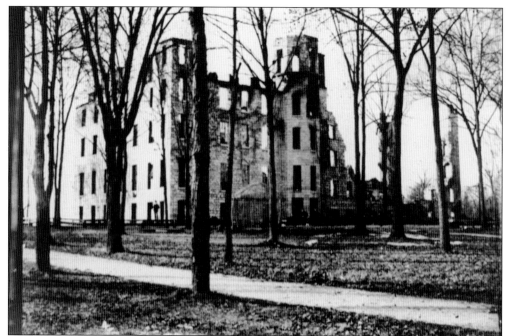

Monticello Female Seminary celebrated its 50th anniversary on June 12, 1888, under the leadership of its third principal, Harriet Newell Haskell, who was appointed in 1867 and continued for 40 years. On November 4, 1888, a fire destroyed the building and its contents of valuable books and works of art, resulting in an estimated loss of $375,000. Due to Haskell's cool and calm demeanor during evacuation, no lives were lost. Haskell had a temporary wooden structure standing within 60 days, which was lit by gas lanterns and lights and steam-heated; 89 students returned in January 1889 to finish the year. Pictured below are ruins of the original Monticello Female Seminary building.

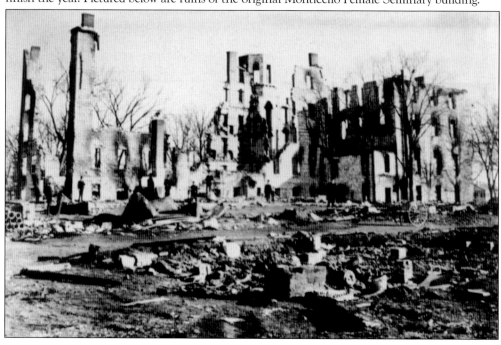

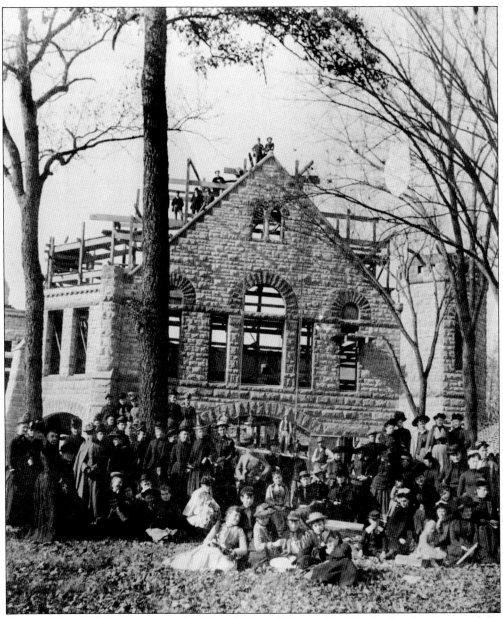

Harriett Newell Haskell saw a new building dedicated 19 months after the fire that destroyed the original structure. Although the original building had only $70,000 insurance on it, widespread awe, respect, and loyalty brought in money quickly to rebuild. The entire edifice is constructed of Corydon, Bedford, and Alton stone, and finished with oak, maple, and hard pine. All rooms in need of a fireplace were made fireproof and a thorough system of fireplugs was installed, connecting with always-full water tanks placed on every floor. This image shows the laying of the capstone at the top of the building known as the Reid Memorial Chapel.

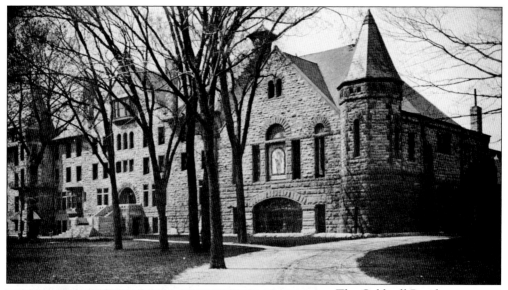

The Caldwell Residence at Monticello Female Seminary, now called Caldwell Hall at Lewis and Clark Community College, stands on the site of the foundations of Monticello's original building, which was at the site in 1838 until it burned down in 1888. Towers distinguish the older Monticello buildings, which have a castle-like appearance.

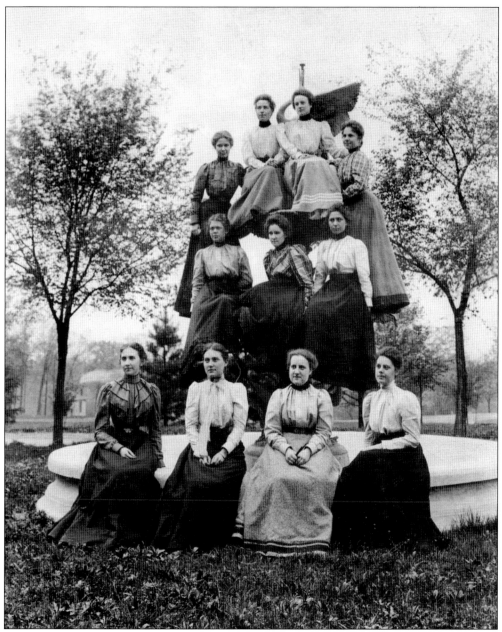

During their graduation ceremony on June 11, 1889, members of the Monticello Female Seminary Class of 1889 (shown above) were involved with laying the cornerstone of the new building that would replace the structure destroyed by fire the previous November. The 1889 exercises were held outdoors on a broad platform, one end of which provided a stage over the excavation for the new structure. Principal Harriet Newell Haskell listed the cornerstone items, which included copies of the *Alton Telegraph* and many other newspapers of the time and a list of new building contributors that was headed by William H. Reid, for whom Monticello Female Seminary named its chapel, which later became the Reid Memorial Library.

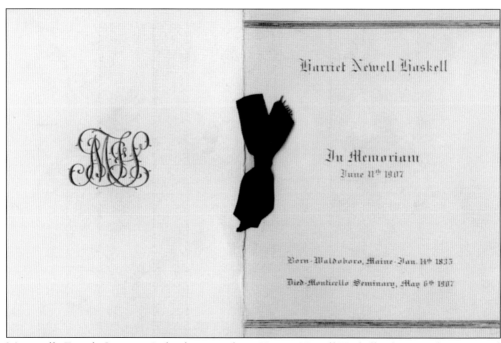

Monticello Female Seminary's third principal was Harriet Newell Haskell, who served as principal from 1867 until she died of heart failure in 1907 at the age of 72. Haskell was one of the best-known women educators in the United States and is credited with rebuilding Monticello Female Seminary. When she discovered insurance covered just $70,000 of damage from the 1888 fire, she went to work raising money and rebuilt the school at a cost of $250,000. It became known in 1904 that the school's entire debt had been cancelled. At the time of her death, the value of Monticello was estimated at $500,000.

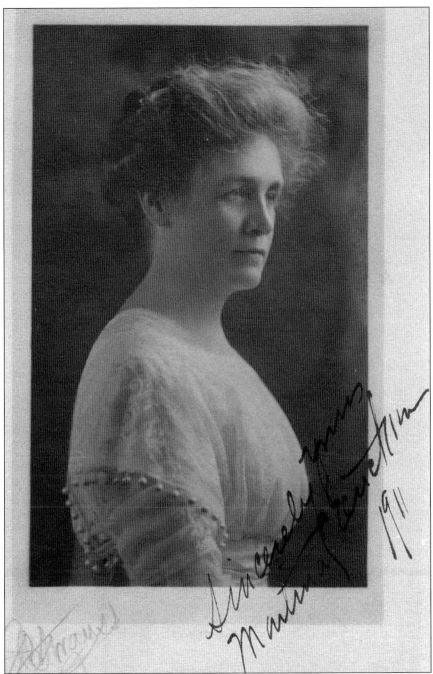

Monticello Female Seminary's fourth principal, Martina C. Erickson, succeeded Harriet Newell Haskell, who left gigantic shoes to fill. A long and tedious search took place for Haskell's replacement following her death in 1907. Finally, Erickson was appointed in 1910 and served as principal until 1917. Under her leadership, Monticello continued to reach new heights of academic excellence. Harriet Rice Congdon succeeded Erickson in 1918; George Irwin Rohrbough became president in 1935 and under his watch built Haskell Hall and transformed the seminary into a junior college for women known as Monticello College.

Baldwin Residence is named for Monticello's first administrative officer, or principal, Theron Baldwin, a Yale educator handpicked in 1835 by Monticello founder Capt. Benjamin Godfrey to head the school. Baldwin Residence adjoins Caldwell Residence to the west.

Shown here is the Harriet Newell Haskell Memorial Gate, erected in 1908, one year after Haskell's death. Monticello alumnae raised funds for the memorial and its installation. The monument marks Harriet Newell Haskell's dedication to the school and the students; it is the first monument dedicated to a woman in the United States. The gateway, which stands at the front of the campus toward the main entrance at present-day Caldwell Hall of Lewis and Clark Community College, figuratively represents the entrance to a pioneer school in the Midwest for women's education. The Godfrey Memorial Chapel stands tall in the background.

Monticello students, seen to the left standing in front of Caldwell Residence, the center of campus life during this period, show the typical style and disposition of its residents. Later, the residence became Caldwell Hall, which no longer houses students as part of present-day Lewis and Clark Community College. The image below is that of a student reading in her resident dorm room.

These are historical buildings from the Monticello College era on the present-day campus of Lewis and Clark Community College. Many weddings, receptions, and other events are held at the community college because of the beauty of the campus and buildings.

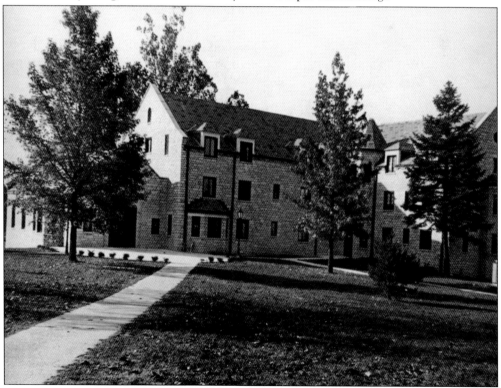

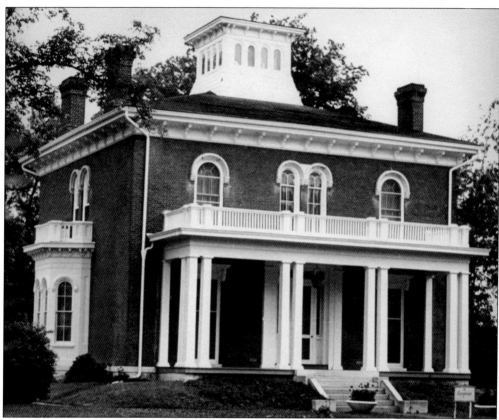

The Evergreens, originally a private home, was purchased by Harriet Newell Haskell in the early 1890s and became part of the Monticello Female Seminary campus upon her death in 1907. In 1935 it became the home of the presidents of Monticello College. It still stands on the campus of Lewis and Clark Community College and is the office of the Monticello College Foundation.

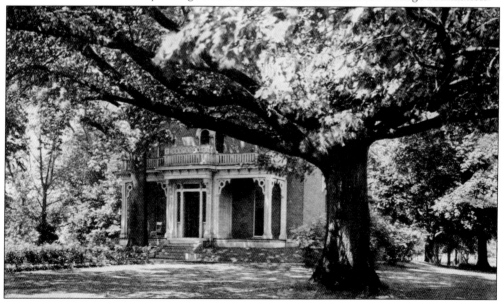

Monticello students were admonished to "remember who you are and what you represent." The students were to be the embodiment of the teachings of the school. At right, a student poses in front of Caldwell Residence. The image below shows a student sitting on the steps to the majestic entrance of the main building, Caldwell Residence.

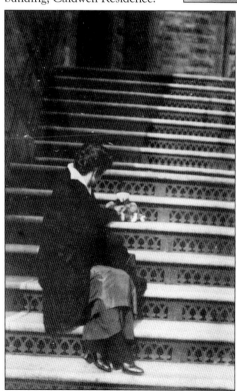

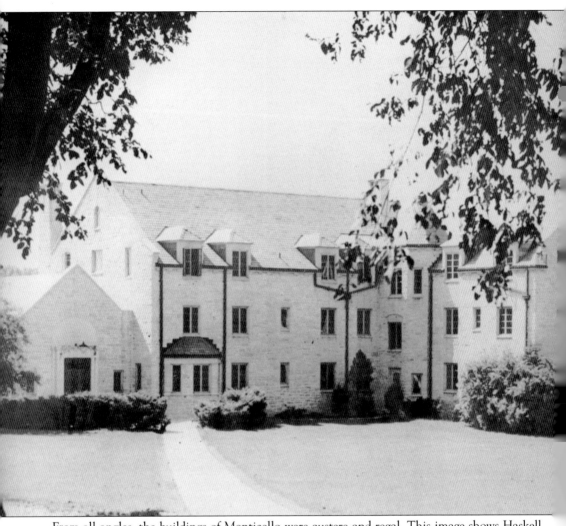

From all angles, the buildings of Monticello were austere and regal. This image shows Haskell Hall, a residence hall for students.

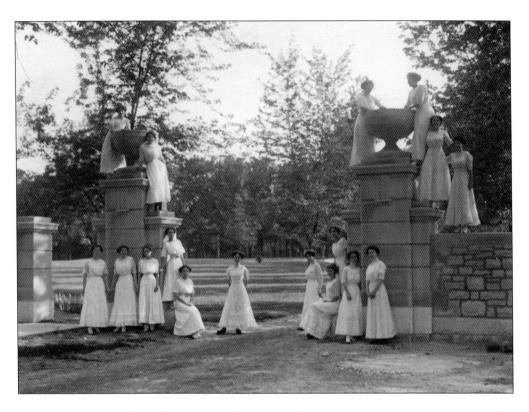

Pictured above are Monticello students from the 1920s posing at the roadway entrance to the campus. Below, students from the same era are at an outing along the Mississippi River.

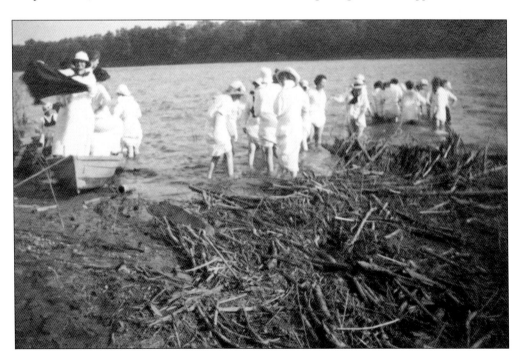

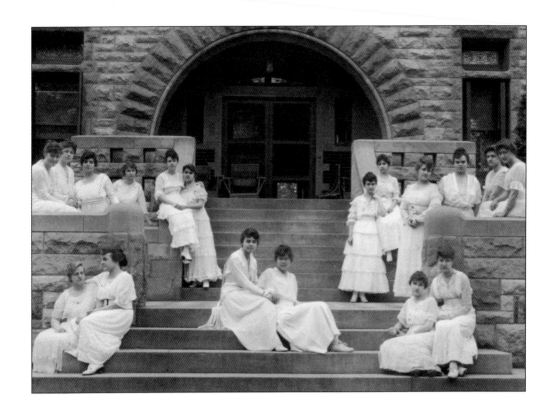

In the 1900s, Monticello students wore white dresses for class day and graduation. The color and formality of dress represented students' growth in dignity, grace, and knowledge; it was Monticello's mission to promote such growth. Obviously, fashions varied during Monticello Female Seminary's early years, as evidenced in the image below, which shows students in the 1800s dressed formally in dark colors and dramatically plumed hats.

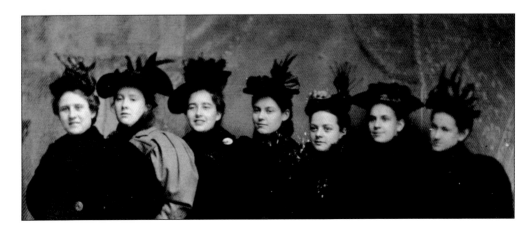

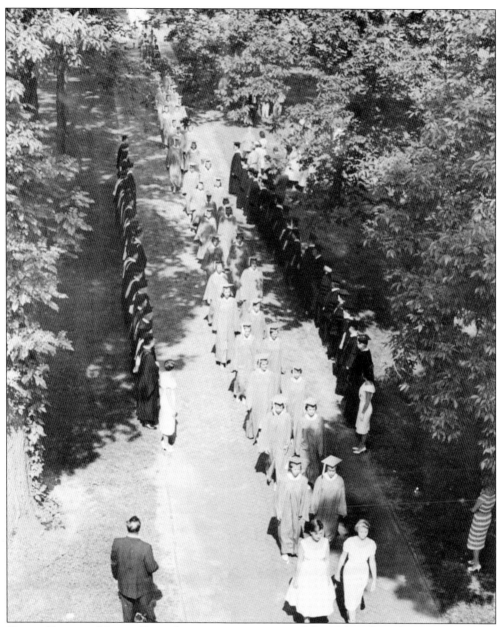

Pictured here is a Monticello graduation ceremony, around the 1960s, when the manner of dress became more modern and seemingly liberated along with the times. The white dresses were covered with white graduation robes and mortarboards were worn on their heads.

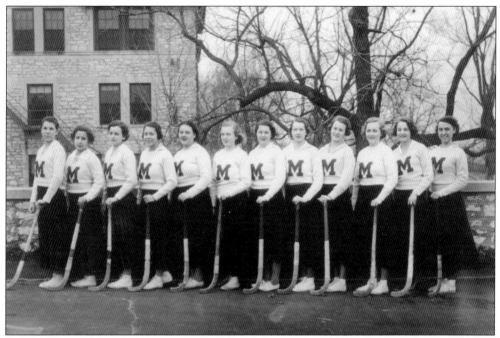

Monticello's athletic program was designed to promote teamwork, sportsmanship, and health, which were meant to carry over into the classrooms, such as in the science lab seen below. Students were also encouraged to acquire enough proficiency in individual sports to provide a source of recreation and pleasure. The field hockey team, above, maintained intramural and intercollegiate games.

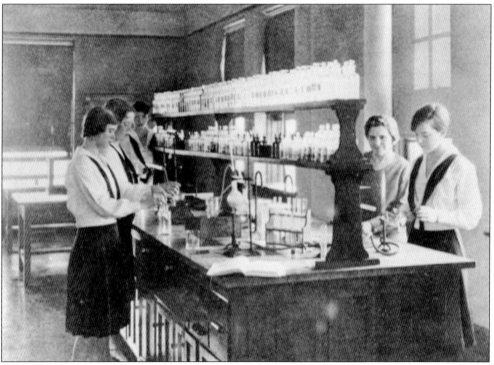

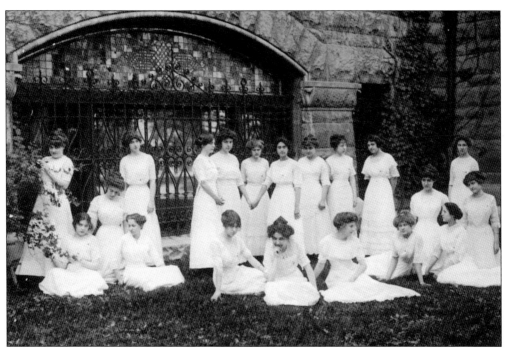

Monticello Female Seminary's master campus plan was designed by German architect Theodore Link in 1889. Graduating students, such as the students pictured here standing in front of handcrafted wrought-iron gates, used areas of the campus as backdrops. Link was also the architect for the historically significant St. Louis Union Station, designed in 1891, and was an architect for the 1904 World's Fair held in St. Louis. The image below shows students doing performance art on the steps in front of the main entrance to Caldwell Residence.

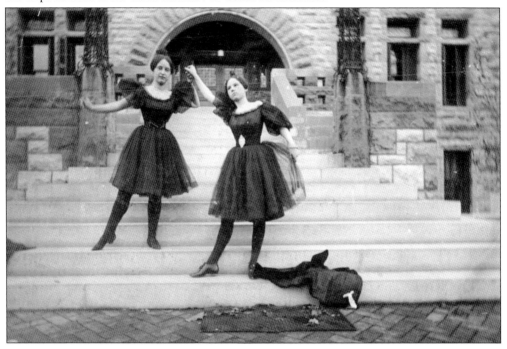

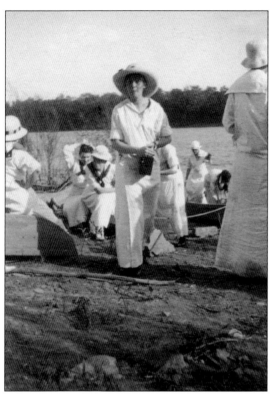

Monticello Female Seminary students'
outings included boating and swimming
off the banks of the Mississippi River and
walks through the gardens on campus.

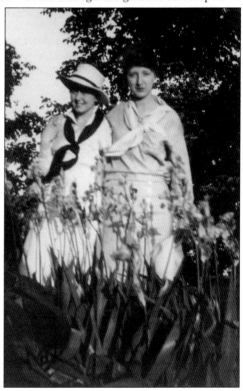

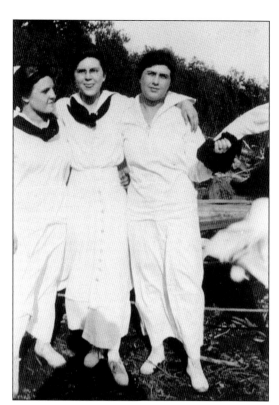

During this earlier era, young women dressed nearly fully clad to swim. Monticello accepted students from all walks of life, from a farmer's daughter to Capt. Benjamin Godfrey's very own girls.

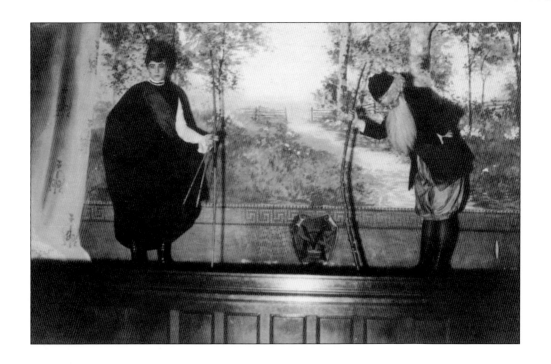

Monticello Female Seminary emphasized the fine arts as a way to nurture the real pleasures of leisure time. Students were particularly drawn to the theater arts and held several dramatic plays a year.

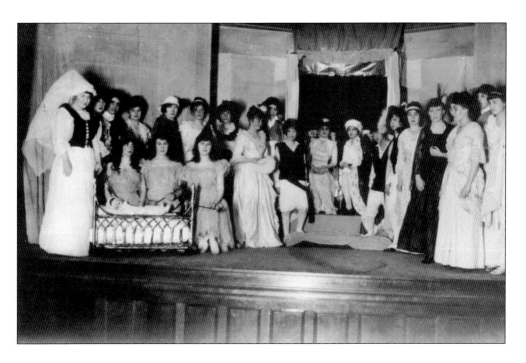

Three

LIVING OFF THE LAND

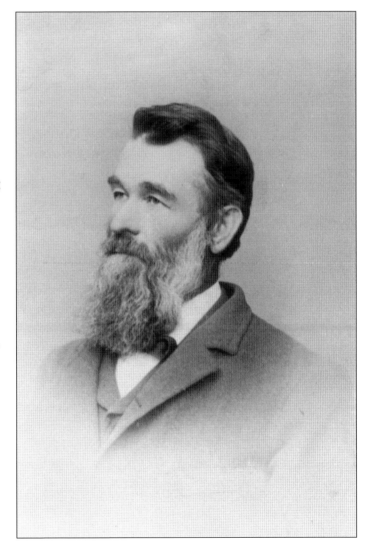

The patriarch of one of Godfrey's earliest founding families, Emil A. Riehl, who went by E.A. Riehl almost exclusively, built the original Riehl house in 1863. Godfrey's Riehl Lane is named for the patriarch. The road runs off West Delmar Avenue, also known as Illinois Route 3, and leads back to the family homestead atop a river bluff overlooking the Mississippi River, where his immediate family lived. Erwin A. Thompson, Riehl's grandson, and his extended family still live on the multi-acre homestead today, where Thompson and his wife, the late Ruth Evelyn Johnston Thompson, raised their three children

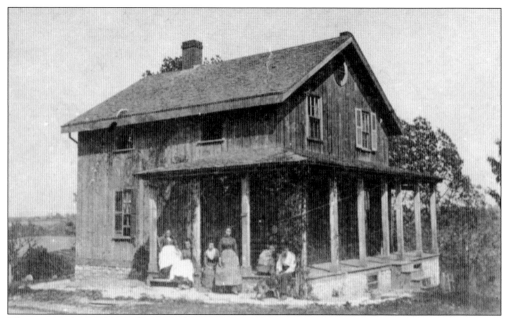

The image above shows the main house that Riehl first built, which today has 14 rooms on the main levels, 5 porches, and 8 rooms in the basement, which still has remnants of a cistern that caught water and channeled it for the family's use before there was indoor plumbing. The original siding was white pine, installed vertically with barn battens to cover the cracks.

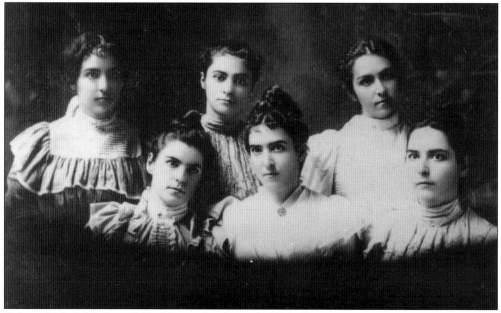

E.A. and Mathilda Roesch Riehl's six daughters, half of whom resided on the family homestead in Godfrey most or all of their lives, first helping their invalid mother and then helping their father manage the ancestral property known to the family as Evergreen Heights (named for the property's pine rows). Shown here are, from left to right, (front row) Alice "Ali," Helen "Nell," and Emma "Em;" (back row) Julia "Judie," Anna "Annie," and Amelia "Mim." The Riehls also had three sons: Frank, Edwin "Ed" Hugo, and Walter.

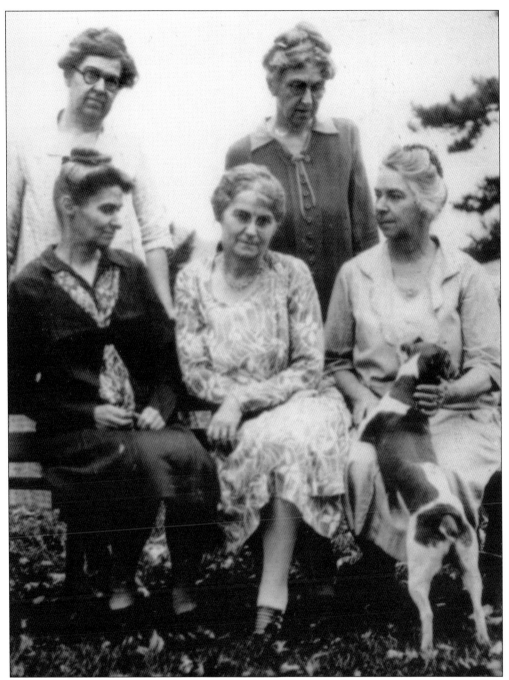

In this photograph, taken on a Sunday in October 1929, are the five surviving daughters of E.A. Riehl and his wife, Mathilda; their daughter Helen "Nell" died of cancer in 1925. Shown are, from left to right, (front row) Anna "Annie," Alice "Ali," and Emma "Em;" (second row) Julia "Judie" and Amelia "Mim." A week after this photograph was taken, Anna was killed by a passing vehicle near her home in Rushville, Ill. This was the last time the sisters spent time all together. Alice had come to visit her family home from her home in Olympia, Washington. Anna's son Ralph made sure his mother saw her sister by driving the 200-mile round trip from Rushville.

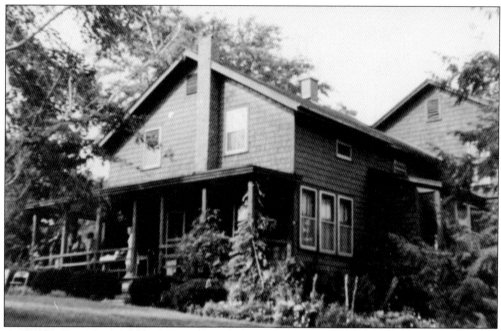

Pictured is the main Riehl house as it was when Riehl's grandson Erwin A. Thompson came to live there in 1916 when he was nine months old. The family called the porch on the first floor the eating porch and the roof above it the sleeping porch.

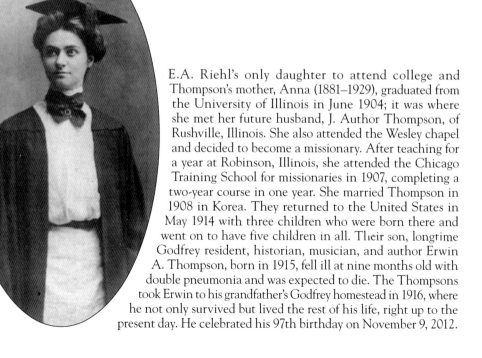

E.A. Riehl's only daughter to attend college and Thompson's mother, Anna (1881–1929), graduated from the University of Illinois in June 1904; it was where she met her future husband, J. Author Thompson, of Rushville, Illinois. She also attended the Wesley chapel and decided to become a missionary. After teaching for a year at Robinson, Illinois, she attended the Chicago Training School for missionaries in 1907, completing a two-year course in one year. She married Thompson in 1908 in Korea. They returned to the United States in May 1914 with three children who were born there and went on to have five children in all. Their son, longtime Godfrey resident, historian, musician, and author Erwin A. Thompson, born in 1915, fell ill at nine months old with double pneumonia and was expected to die. The Thompsons took Erwin to his grandfather's Godfrey homestead in 1916, where he not only survived but lived the rest of his life, right up to the present day. He celebrated his 97th birthday on November 9, 2012.

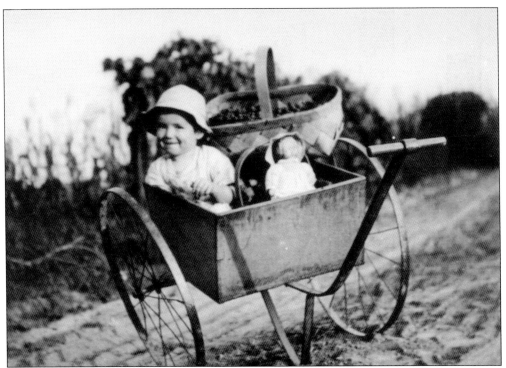

Erwin A. Thompson is pictured sitting in a cart made by E.A. Riehl for his daughters to transport vegetables and fruit from the Riehl homestead garden and orchards; they shared their bounty with neighbors. When Thompson came at nine months old to live at the family homestead, known as Evergreen Heights, Riehl and his three daughters, Julia, Emma and Amelia, lived at the homestead. The women accepted giving up the opportunity to marry to take care of their invalid mother, Mathilda, who was Thompson's maternal grandmother; she died in 1910. Thompson's three aunts cared for him, but Amelia, or Aunt Mim, became Thompson's chief caretaker.

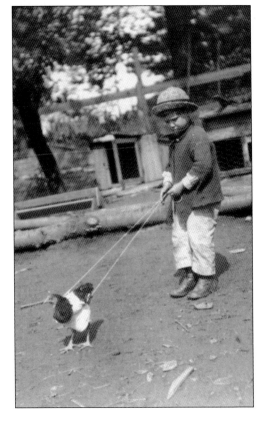

As a young boy, Thompson had a pet chicken that he remembers as "one of the best pets I ever had." Although he does not recall how they came together, the Riehls raised chickens among many other farm animal species, including hogs and cattle.

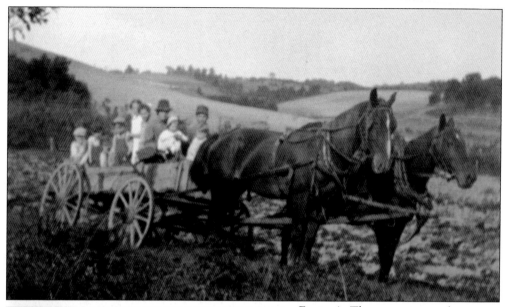

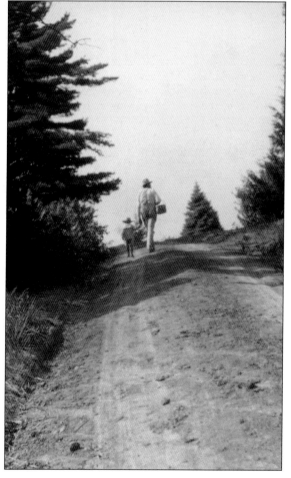

Erwin A. Thompson is seen here as a child, sitting on the lap of farm hand Jim Bowman. Riehl and Bowman family members went to the pasture on the working farm at the homestead of Thompson's grandfather to gather black walnuts. The Riehl family referred to the area in which the team is pictured as the east bottom, where Chestnut Street is today. The east line of the Riehl property was and still is the east line of Jersey County. The former adjacent Stanka farm, also in Godfrey, was in Madison County.

Thompson is shown here at about age four, walking hand-in-hand with his grandfather on Riehl Lane that leads out onto present-day Illinois Route 3, also known as West Delmar Avenue. The treetop just over the hill to Riehl's right is a blue spruce, for which he was offered $500 but declined it. The species back then was considered a rare article.

When Erwin A. Thompson was around three years old, he rode to town in this sleigh, pulled by a mule team the day this photograph was taken. The family called the mule on the right Old Jack; he was always impatient and ready to pull, as seen by the way he is pawing at the snow.

This is just above where the road takes off to the west bottom, which was part of the Riehl property. Thompson's aunt Amelia "Mim" Riehl is trying to restrain her boisterous nephew, then about four years old.

Erwin A. Thompson's aunt Emma Riehl, with his visiting older sister Eleanor, is seen here by the water tank, built near the grounds' upper cottage around 1916. The tank was built to accommodate overnight guests and boarders, which the Riehls had begun taking in the 1890s. The tank supplied water for guests taking their meals at the Riehls' main house. Water was caught off the roof of the cottage, stored in two big cisterns, pumped into the tank above ground, and sent from there into the kitchen of the main house. The innovation and resourcefulness of the idea made the main Riehl kitchen the only one in the neighborhood with indoor running water. This was an almost unheard of luxury a century ago.

The Riehl homestead's upper cottage's windmill pumped the water from the cisterns up into the tank that was above ground. The tank had to be above ground to give enough fall to put the piped water up into the Riehlses' kitchen in the main house.

The Riehl family, as well as their guests, enjoyed fishing as a recreational activity. Here, Thompson's aunt Julia Riehl is fishing in Godfrey's Piasa Creek, a tributary of the Mississippi River, just above a new bridge (not shown). Visitors and the region's residents still use Piasa Creek today for recreational activities, including fishing, boating, bird watching, and nature trail hiking on grounds surrounding the creek.

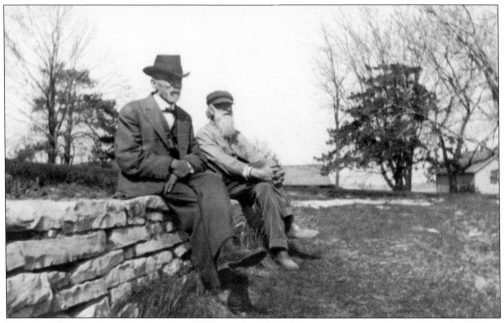

E.A. Riehl (right) and his brother William Riehl (left) are sitting on the wall by the White Cottage on the Riehl homestead. The homestead's barn and a shop are in the background. Families often had several structures for different operating functions on working farms that commercial businesses now provide to families.

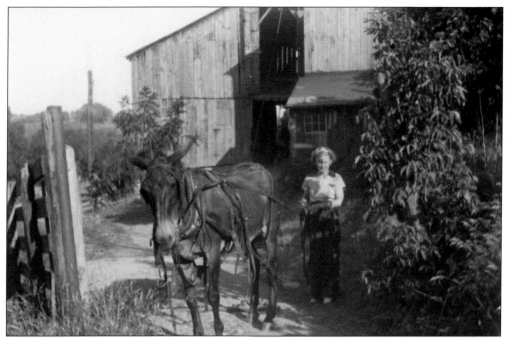

Erwin A. Thompson's cousin Lillian Mueller stands behind the Riehl barn around 1935. While men were putting up hay, Mueller drove the Riehls' mule Old Jack. The youngster who also helped put up hay and helped Thompson learn to play music was ahead of her time by wearing slacks. Thompson's grandfather E.A. Riehl built the barn after building the main house. The family raised a variety of livestock, including pigs, hogs, and cattle, and they kept horses for manual labor and transportation. Outside the barn, there was a chicken village with multiple chicken houses. Riehl equipped the barn with a large fork lift, tack room, a loft, stables, and mangers for cattle. Five acres up a wagon road from the barn, the family raised their own hay for horses and other beasts of burden. Across from the property's pine rows existed an alfalfa field; nearby, 100 yards' worth of blackberries grew.

Another member of Thompson's extended family, his uncle Frank Riehl, is seen here in a homestead pasture with his gun. A picket fence can be seen in the background.

56

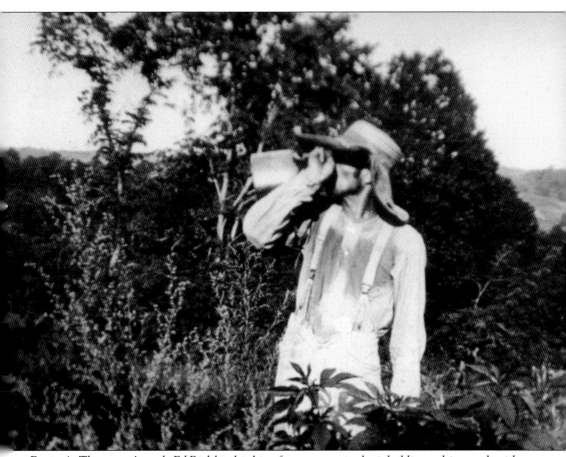

Erwin A. Thompson's uncle Ed Riehl is drinking from a water jug he is holding to his mouth with one finger. It was quite an accomplishment to drink from a jug with one hand.

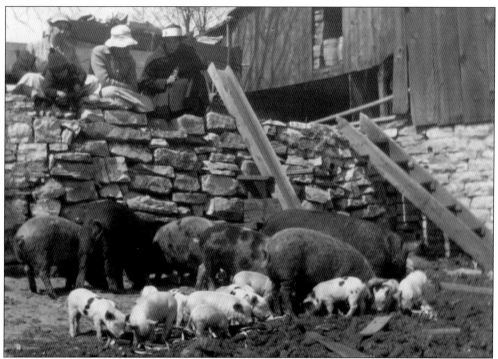

Erwin A. Thompson's aunts are tending to the hog lot behind the Riehl barn. Pictured to the right of Thompson's aunt is a chute that sent kitchen waste to the hogs for them to eat.

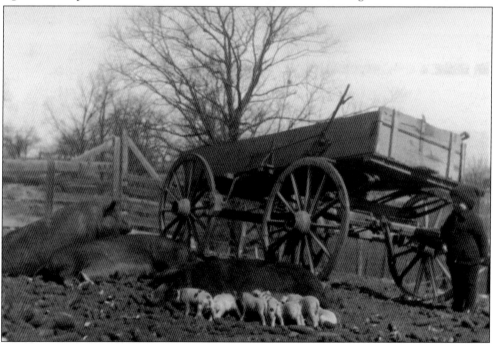

Erwin A. Thompson, at about age four, is standing in the hog lot next to a utility wagon behind the Riehl barn. The wagon was filled with ear corn, which the hogs were fed by scooping the corn from the wagon to the ground. Hogs were common animals on family farms during this period.

In the photograph to the right, Erwin A. Thompson's aunt Emma Riehl's husband, George Gibbens, of Pike County, Illinois, grooms his pet calf. Riehl married Gibbens in September 1919. Gibbens also became involved with Godfrey's former Melville Congregational Church, seen below, that once stood on West Delmar Avenue (Illinois Route 3) just east of its intersection with Clifton Terrace Road. E.A. Riehl donated money for the church, which he also helped build. Although Riehl was not a "church-going man" because he found communication with God through nature, he believed every community needed a church for fulfillment of those who felt the need to worship in a group, as well as for marriages and funerals. Riehl's son, Frank Riehl, served as superintendent of Melville Sunday school.

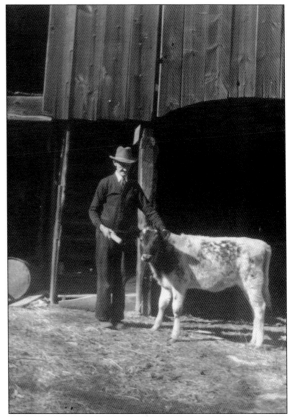

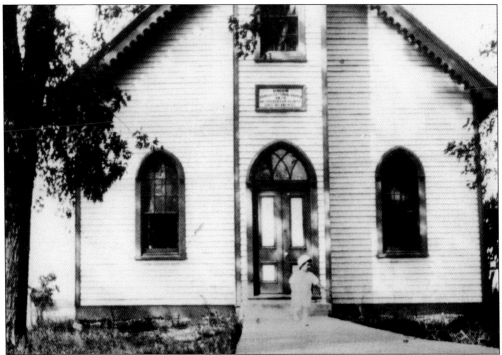

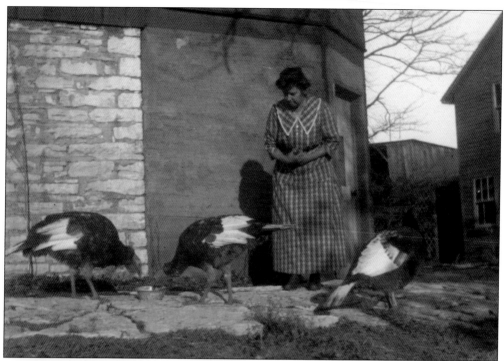

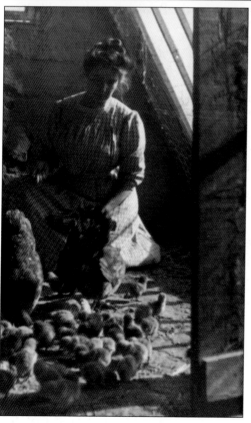

Julia "Judie" Riehl, seen above, tended to her turkeys at the back of the main Riehl house where it met the basement, which provided an eating porch for the animals. Judie's sister Emma tended chickens; she is pictured to the left with her chicks in the little "Bluff House" that her father made to take advantage of solar heat long before the idea came into the public consciousness. Riehl built the structure into the hill, with one side almost entirely below ground, while the all-glass side of the structure faced the Mississippi River. He made the glass panels from cold frame sash, with the top sloping back toward the roof so as to catch the sun better. The captured heat was ideal for early chickens. Dressed chickens were unavailable in grocery stores, where they are sold packaged today; thus, the Riehls' dressed chickens provided income for the family during the early 1900s. In the late 1800s, they profited from boarders who ate the dressed chickens.

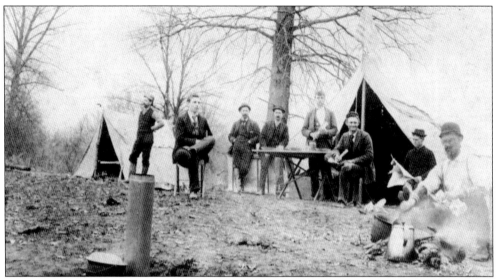

Erwin A. Thompson's uncle Frank Riehl became a hunter during his earliest years. The photograph above shows a hunting party to which he belonged. Riehl developed his fine shooting ability throughout his lifetime. He began hunting for pleasure and for whatever game he might harvest. Later, these skills became a part of his livelihood when he became an agent for the Western Cartridge Company, which became Olin Corporation in 1944, located in East Alton, that sold its products worldwide. Riehl represented the company in the Pacific, Australia, and India. Through his shooting skills, Riehl promoted the sale of Western ammunition. He won the title of World Champion Marksman once during his lifetime, and Western Cartridge Company used this fact in its advertisements, promoting "World Champion Ammunition!" Thompson said he believes that Riehl is pictured above to the right directly seated in front of the tent, looking at a document. In the image below, Frank Riehl, at the far right, is pictured with his hunting buddies, the McAdamses. The ducks the men shot are strung behind them.

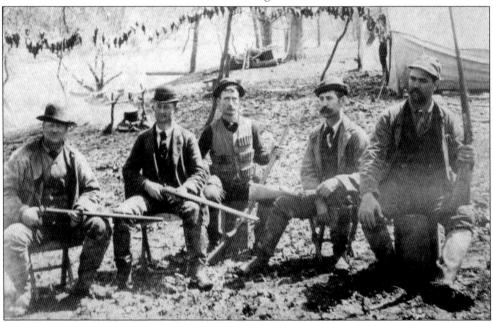

The Hoffman family, whose farm was located along present-day Beltrees Road and Piasa Creek, a tributary of the Mississippi River, were avid foxhunters, and foxhounds were their love and pride. The family's hunters followed the hounds wherever the hounds' noses took them. On a clear night, neighbors for miles around could hear the hounds as they followed their quarry through the fields, over fences, and through pastures and woods. Piasa Creek today is accessible from Piasa Harbor, located just off the present-day Great River Road, also known as Illinois Route 100. (Courtesy of Verna Hoffman.)

The children of Erwin A. Thompson are shown here with a slaughtered pig that they butchered while their father was hospitalized likely because of a horse kick. The children—Julia, Gary, and Janet—called their dad at the hospital to ask how to go about slaughtering the pig, which their great-grandfather E.A. Riehl had given Gary, who raised it as a 4-H project. Thompson told his children what to do step-by-step to dress the pig.

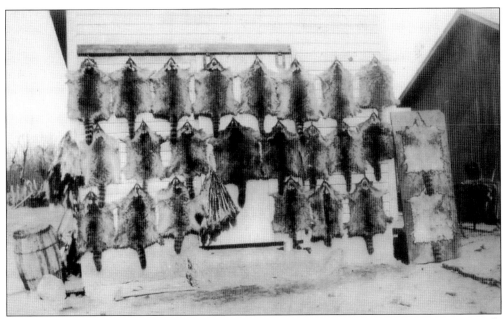

The Hoffmans hosted "coon" hunts, which were different than foxhunts. Raccoons were not only good eating, but their pelts were worth considerable money, even during the Great Depression. Raccoons could only be hunted in the proper season. Finding a treed coon sometimes was a challenge, but the sound of the dogs' barking was a reliable guide. Pictured are numerous coon pelts hung up after a hunt. (Courtesy of Verna Hoffman.)

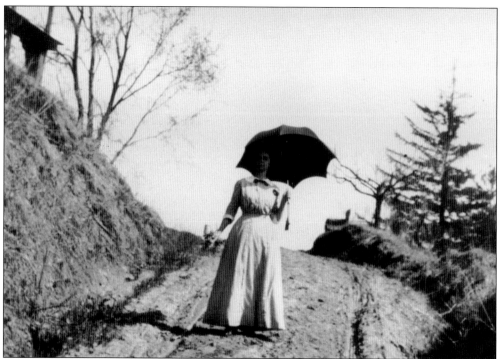

Emma Riehl is seen here walking down the road on Riehl homestead acreage that led to the west bottom. Riehl carried the umbrella for sun protection. The Riehls' upper berry shed can be seen just barely in the upper left. The Riehls used these sheds as a place to gather quarts of berries picked by the Riehls' neighbors and members of their community. The Riehls credited the pickers by notating how many quarts they picked. Credits were tallied at the end of the day and if the picker desired to collect at that time, they were paid. Otherwise, the tally remained on the books and the picker received payment at the end of the week. Thompson's uncle Edwin Hugo Riehl grew berries in the adjacent community of Alton, Illinois, and was named "King of Fall-Bearing Strawberries."

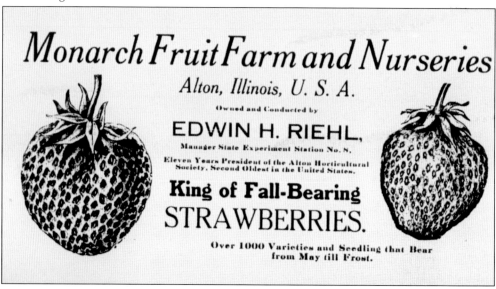

Godfrey patriarch E.A. Riehl utilized several different crops and commercial plants. This scene shows peony fields between the pine hollows, where Riehl had cleared brush from the ravines and planted evergreens on slopes too steep to farm. Peony fields lay between these hollows. A row of chestnut trees is seen in the distance to the right.

This 1935 image shows Erwin A. Thompson, right, with his friend and farmhand John Veltjes in a field during peony harvest. Veltjes did the cutting on this particular day, which involved selecting individual buds that were at exactly the right stage to continue to open after being cut; the buds were left in an early opening stage so as to withstand shipping and storage until Decoration Day. Thompson carried and received the cut flowers this day from Veltjes, who usually did the carrying while Thompson cut. The person carrying the cut flowers took them to the end of the harvested peony row to be deposited into the carrying box and thence to the basement of the Riehls' upper cottage to be packed and shipped.

This is the American chestnut tree that E.A. Riehl topworked by grafting small twigs, or scions, of the Italian strain into the top of the tree, creating a hybrid nut. When the tree bloomed, the two varieties cross-pollinated and the nuts were therefore hybrids. The next season, he planted the nuts; when the new trees bore, he examined and tested the nuts carefully. From these he developed the varieties that became well-known in the horticulture world.

Considered among the top 10 horticulturalists of his day, Riehl gained acknowledgement for his success with several different plant species, as this certificate of honorable mention for Riehl's exhibit of persimmons at the Pan-American Exposition in Buffalo, New York, shows. He also received a gold medal for his fruit at the 1904 World's Fair in St. Louis. Riehl was a charter member of the Alton Horticultural Society and the Illinois State Horticultural Society.

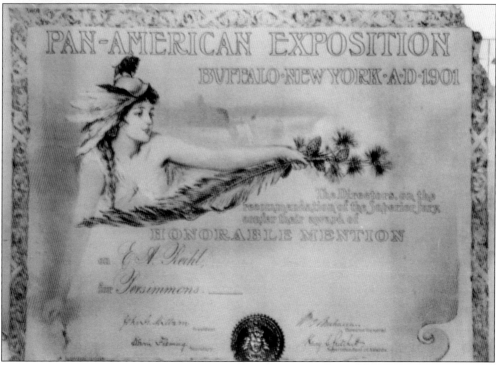

E.A. Riehl, spent the first 20 years of his life in Godfrey establishing the Riehl homestead and making money to pay the mortgage, but he eventually became a prominent horticulturalist. He is pictured here with a chestnut sapling, the result of his cross-pollination. It took years of patient work, but eventually he propagated the new nut varieties and planted the trees in the pastures. Riehl's success with the nuts came around 1915.

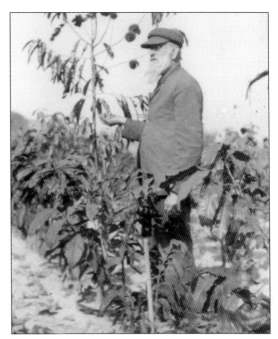

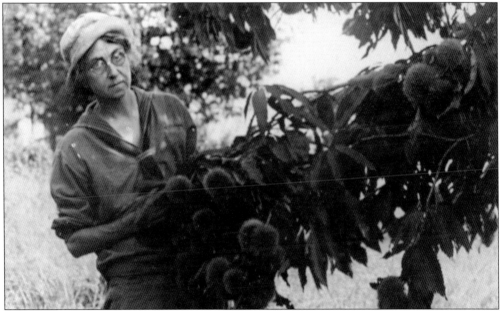

Each fall, the Riehls harvested the nuts. Chestnut harvests pulled the family through the Great Depression. The family also propagated the varieties in the Riehl tree nursery and sold the trees. Around 1930, the Riehls began seeing signs of the disease that had wiped out the American chestnuts in the East. They fought the disease by trimming and burning all of the infected branches; sometimes, the whole tree had to be destroyed. In 1935, a black locust plague carried the disease throughout the Riehl orchard, and their methods of control became useless. By 1940, the Riehl chestnuts were a thing of the past. Riehl's daughter Amelia, "Mim," shows one of the varieties of nuts in the bur, which was the protection provided by nature for the nuts. The US Department of Agriculture took this photograph.

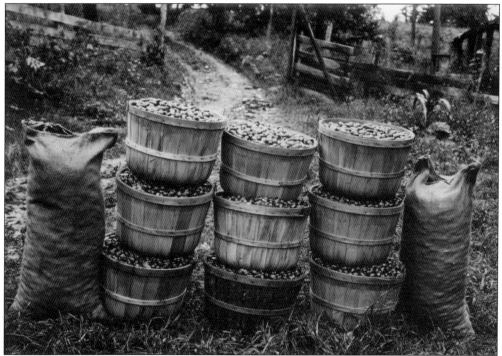

Shown above are 700 pounds of chestnuts, ready to be sacked up and shipped. The nuts were sorted according to size by a hand-operated rig that was originally made for sorting sweet potatoes by size; nuts were graded according to size. People of the Eastern United States preferred the small American chestnut, which was very sweet, whereas the original larger Italian nut had a poor flavor. This was the purpose of Riehl's cross-pollinating work of crossing the two strains, thereby creating a variety that had the size of the Italian nut and the flavor of the native nut. People of the upper Midwest who were of European descent, like many steelworkers in Ohio, preferred the Italian nut, which reminded them of their European heritage.

The chestnuts were stored in bushel baskets, as shown here, while waiting to be sorted and sacked for shipment to either Cleveland or New York. The chestnut blight wiped out the eastern US chestnut groves and forests. The picture to the left is a closeup of a chestnut bur on the limb; the bur held the nut inside.

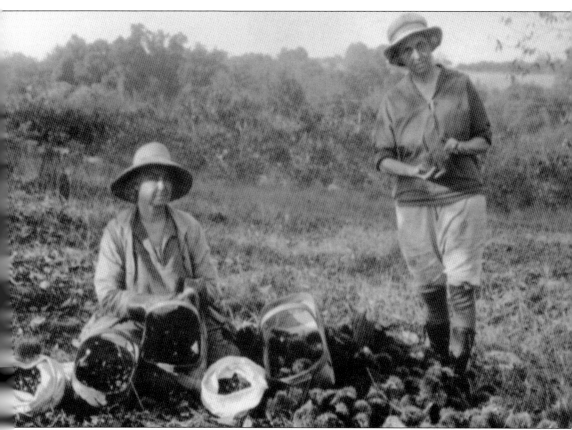

Emma "Em" (left) and Amelia "Mim" Riehl are seen in this US Department of Agriculture photograph at the burring pile. The University of Illinois designated Riehl's farm as an experiment station, seeking and listening to Riehl's opinion on the value of a wide variety of horticulture products that he produced. On the right, Amelia Riehl is shown wearing knickers. Women wearing trousers in these days were practically unheard of. Riehl fashioned her first pair of trousers from US Cavalry surplus from World War I; later, she found knickers, as shown in the photograph. Tall boots were her trademark all the years she worked outdoors.

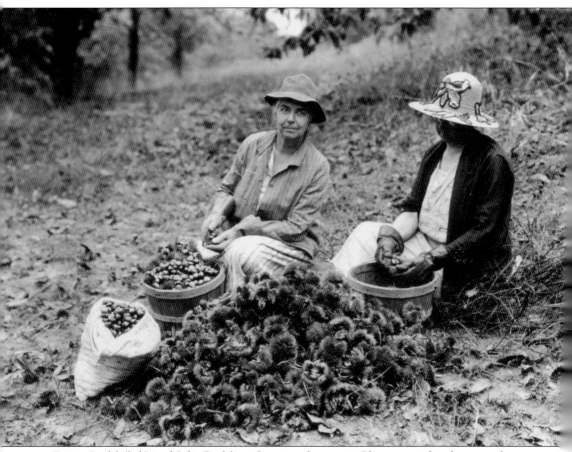

Emma Riehl (left) and Julia Riehl are burring chestnuts. Chestnut orchards covered acres at the Riehl homestead on the bluffs above the Mississippi River along the Great River Road. The Riehls produced thousands of pounds of chestnut product during the lifetime of the chestnut orchards.

This pasture scene shows how most of the chestnut trees were planted on hillsides too steep to farm. The Riehls used sheep to keep the weeds down under the trees; however, sheep had to be kept away from the trees at harvest time because the animals ate the chestnuts.

The Riehls grew and harvested other produce on their homestead's west bottom, shown here. The low bottom produced corn; at this time, the corn was cut and placed into shocks, 16-hills square. Then the corn was husked and the grain was taken to the crib. Corn fodder was not overly nutritious, but it had food value in it and the stalks made a good manure base if left to rot long enough. The west bottom's upper part, which did not flood although the entire west bottom was along the Mississippi River, produced timothy hay. The Mississippi River can be seen in the photograph at the far upper left. Its tributary Piasa Creek is just beyond the Riehl corn field. The Locks' farm adjoined the Riehl farm and lay to the west, or the upriver side of Piasa Creek, while the Riehl property lay on the east, or downriver side. The Locks' low bottom property was located across Piasa Creek from the Riehls' field, where there was a growth of trees on the Lock property, separating the overflow part of the bottom from the higher ground.

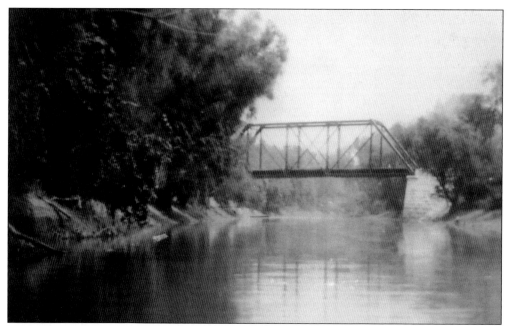

Pictured here is the railroad bridge across Piasa Creek, located in Godfrey and a tributary of the Mississippi River. This was the second bridge, also referred to as the new bridge by longtime Godfrey residents, built to withstand the weight of passing rail engines; the first bridge proved to be too unstable. The foundations for the original bridge, quarried from brown rock found on the Riehl property, could not withstand the weight of rail engines. Foundations for the second bridge were made from rock shipped in from Minnesota, but the local stone brown rock can still be seen in the foundational structure today in foundation ruins, about 100 yards upstream from the Piasa Creek put-in spot at Piasa Harbor off the Great River Road.

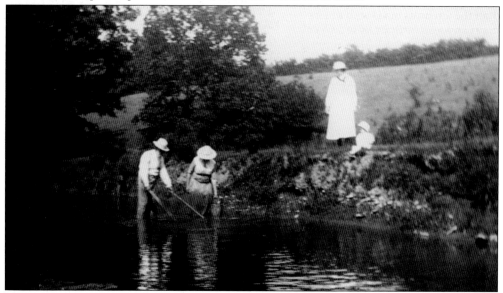

The Riehls also utilized other river runoffs. Patriarch E.A. Riehl is seen here seining minnows in Mill Creek with his daughters Emma. Julia is standing on the bank with her toddler nephew Erwin A. Thompson. Thompson said someone likely took the photograph with Julia's 620 box camera.

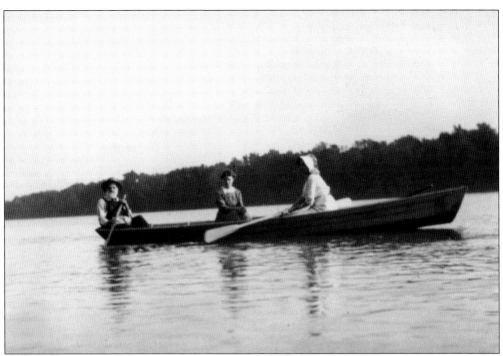

Patriarch E.A. Riehl designed and built the skiffs that the Riehls used on the Mississippi River. Two of Riehl's daughters and Riehl's brother Will, far left, are in one such vessel. Riehl's skiffs were easier to row and maneuver than the jon boats made with square fronts and rears, utilized by most local river users at the time. Riehl's design made the skiffs easier to navigate.

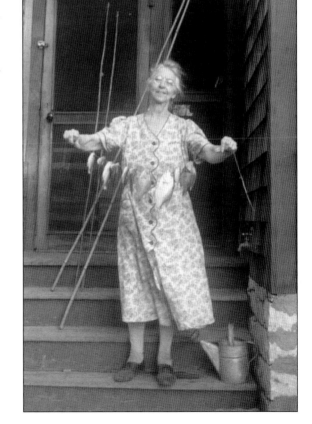

Emma Riehl is pictured here in later years, standing on the back porch of the main Riehl house with a string of fish. Cane poles, shown leaning against the porch wall behind Riehl, were the popular choice used to catch fish and they were commonly sold at hardware stores.

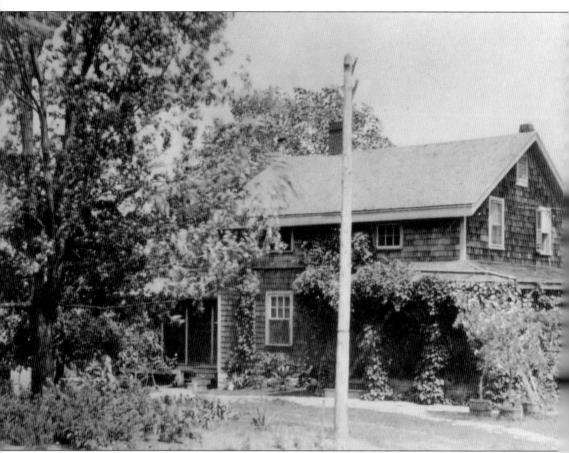

Pictured here is the Riehls' main house, known among the Riehls as the "Big Brown House." After patriarch E.A. Riehl bought the land, he built the main parlor, which now is commonly known as a living room or front room. Eventually, Riehl's grandson Erwin A. Thompson's wife, Ruth, planted at least 500 varieties of day lilies and show gardens on the grounds surrounding the main house. Later yet, a telephone company installed a utility pole on the Riehl property; the telephone pole pictured was known as part of the Grafton line, built to carry communications to and from Grafton. Notably, the Riels had a telephone as long as Thompson remembered; an advertisement about the Riehls' boarding accommodations that began operating in the 1890s included a telephone number. The utility pole shown in this picture was taken down in the late 1920s. But, despite the number of years that have passed since Riehl built the family home place, the ancestral home remains much as it did in its earlier years, with its outbuildings and residential cottages still standing, albeit with modifications making the structures more practical for today's lifestyles.

Second-generation asparagus farmer Benjamin Droste and his wife, Anna, both deceased, recorded their family's history in Godfrey from the early 1920s; the family grew one of Godfrey's most important cash crops—asparagus. Ben Droste's grandfather, Theodore Nicholas Droste Sr., a third-generation farmer, was the first to farm asparagus within the Droste family, whose patriarch Theodore Droste Sr. emigrated from Westphalia, Germany, and established the 80-acre Droste homestead in Godfrey. Ben recalled that farmers in Godfrey Township at one time grew and shipped asparagus from 1,400-acres of land. This image shows the Droste home, built by Droste Sr., on present-day Airport Road in the late 1800s. It was built to replace the first house, which burned down a few years prior on the Droste homestead in Godfrey. The family farm's sawmill, used for making asparagus crates, later on made the lumber for the Drostes' hog house and for the first two rooms of Ben and Anna's home, which started as a two-room house. The couple had 16 children and lived on the family homestead for 24 years. During asparagus crate-making days, a good day's work produced 84 crates of asparagus, all cut, grated, bunched, and ready to be taken to the railcar in Godfrey for shipment to a fresh vegetable market in Chicago. (Courtesy of George Droste.)

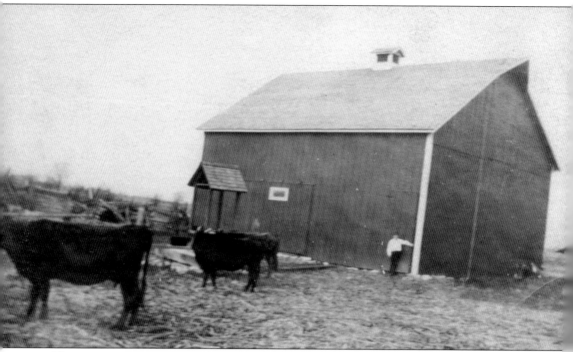

The prominent asparagus-producing Droste family's barn on their farm, pictured here, is where generations of Drostes produced machines and wooden crates used to harvest and ship asparagus. For 16 seasons, multigeneration farmer Ben Droste and his father would cut about 16 cottonwood trees each winter, saw them up on their sawmill, dry the lumber, and make their own asparagus shipping crates; it saved them from having to buy factory-made crate material. The Drostes were among other prominent asparagus-growing Godfrey families including the Koellers, Bachmans, and Joehls. In 1938, J.B. Koeller and Henry Bachman returned from an observation tour of leading asparagus farms, as well as plant breeding and canning factories in New Jersey, where the freezing of asparagus was still on an experimental basis. Although a good cash crop, asparagus was extremely labor-intensive. Looking for ways to speed up and lessen the work load, Ben Droste also recalled building several versions of an asparagus-packing machine. (Courtesy of George Droste.)

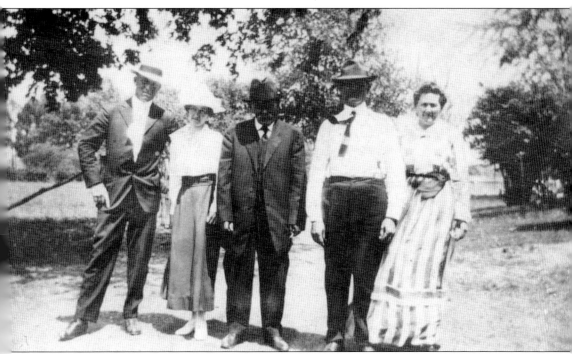

Pictured is prominent Godfrey farmer Theodore Nicholas Droste Sr., center, surrounded by close family friends and fellow farmers on the wedding day of his son Theodore Nicholas Droste Jr. and Mary Brinkman (the couple is not shown). To the left of Droste is prominent asparagus farmer Henry Koeller, and his wife, Eva; to the right of Droste is dairy farmer Ben Brinkman and his wife, Anna, who had a farm on present-day Pierce Lane in Godfrey. In a book Benjamin and Anna Droste and their granddaughter Sarah and daughter Theresa produced and their granddaughter Jessie and her husband Sam arranged to print, Ben Droste recalled that Joe Manns was one of the first farmers in Godfrey to grow asparagus. He remembered Manns going up the road with his asparagus to be shipped by rail to the fresh vegetable market in Chicago. When Ben was about two years old, his father decided that he would plant some of the stalky green vegetable and ordered plants from a nursery. As years passed, old fields fizzled and new ones were not planted. Eventually, labor became scarcer, rail service ceased for lack of volume, and the price received and cost of growing and harvesting made asparagus unprofitable. Regular field crops became more profitable, such as grain and corn; Godfrey's second mayor Michael Campion became a prominent corn and grain grower in Godfrey. However, asparagus always provided early money to pay taxes and clean up back bills. Along with regular crops, it provided the Drostes money to carry them through to the next asparagus season. (Courtesy of George Droste.)

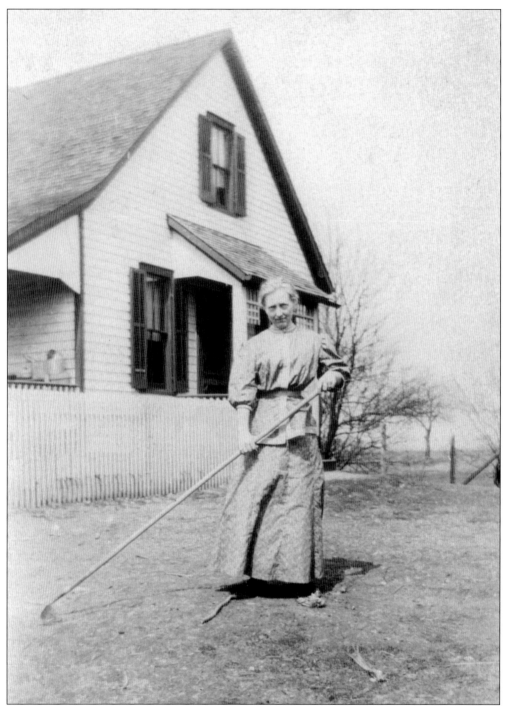

Theodore Nicholas Droste Jr.'s daughter, who later became a nun, Sister Emanuella, is seen here on a visit home. All the Droste family members for generations could and did provide the labor necessary to harvest, sort, bunch, and crate. Asparagus grew on the Droste farm for 48 years. George Droste and his wife, Margie, still live in Godfrey today on Pierce Lane, across the street from Rolling Hills Golf Course. (Courtesy of George Droste.)

Four

HUB OF TRANSPORTATION

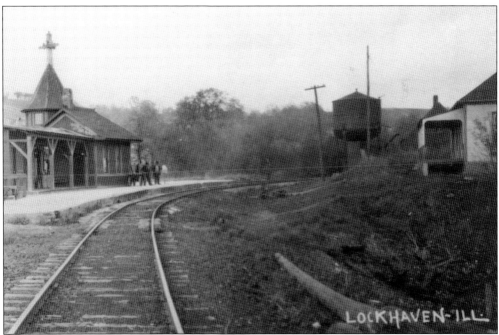

Generations of Godfrey's early families saw the extinction of Mississippi River steamboat traffic, as it was replaced by railroad traffic along the riverbank. Shown here is the Lockhaven Y near present-day Lockhaven Golf Club. Lock family patriarch Charles Edward Lock signed the right-of-way agreement for the railroad tracks seen here on July 15, 1887, for the Chicago/St. Louis, Alton & Springfield Railroad, known to locals as the Springfield Line because it went to Springfield, Illinois, splitting at the Y to go to the state capital, while from that point the Bluff Line went to Alton.

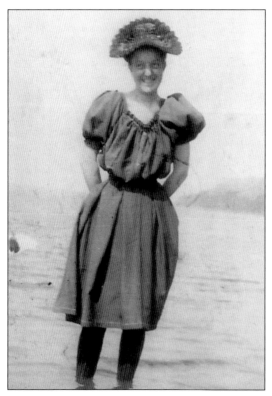

Railroads brought visitors to the Mississippi River's banks, where a female visitor to early Godfrey settler E.A. Riehl's homestead models the swimwear of the day before she takes a dip in the river. Three of Riehl's six daughters lived at the family homestead, Evergreen Heights, and operated lodging on the property in the late 1800s for boarders and short-term visitors. Riehl's daughters Emma, Julia, and Amelia maintained cottages and services for travelers of the day. The image below, shows another one of their boarders drying her hair in the sun on the Riehl property.

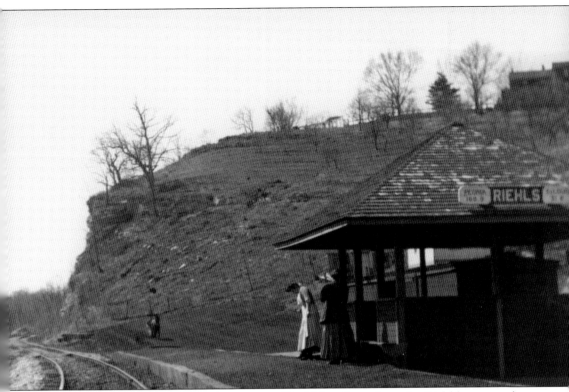

Seen here is Riehl's Station, at the former site of Riehl Landing, where the Riehl house can be seen on top of the hill to the far right overlooking the Mississippi River. The station was named for E.A. Riehl, who signed the right-of-way for a railroad from neighboring Alton, to the southeast, to Grafton a few towns away to the west. Locals referred to this railroad as the Bluff Line, which stopped at Riehl's Station, located in present-day Godfrey Township at the Madison–Jersey County line at the present-day intersection of Stanka Lane and the Great River Road. The Great River Road replaced the old Bluff Line rail route in the 1960s along the Mississippi River. The present-day Vadalabene Bicycle Trail is located on the Bluff line right-of-way and was built by the Illinois Department of Transportation in 1976 as a demonstration bicycle trail for the state of Illinois.

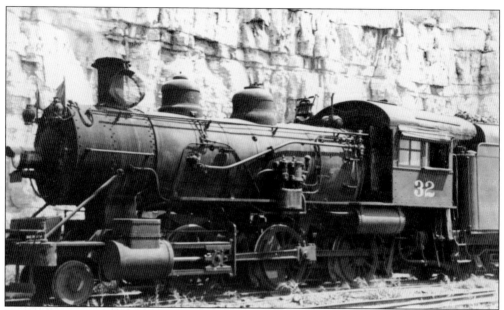

This is a coal-fired engine that furnished the power to pull trains. The image here shows No. 32; this photograph was taken at the terminal in Godfrey's neighboring town of Alton, Illinois, at the Chicago, Springfield & St. Louis Railway terminal, which today is the site of a sand plant. Godfrey founder Capt. Benjamin Godfrey was integral to bringing railroads to the region; he founded and built the first railroads in the area.

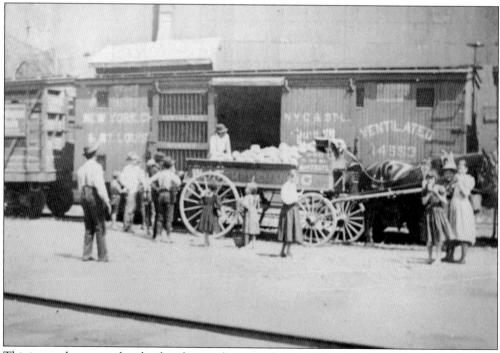

This image shows ventilated railroad cars, where people would load produce to go to outlets around the country, such as a fresh vegetable market in Chicago, where much of Godfrey's asparagus was shipped.

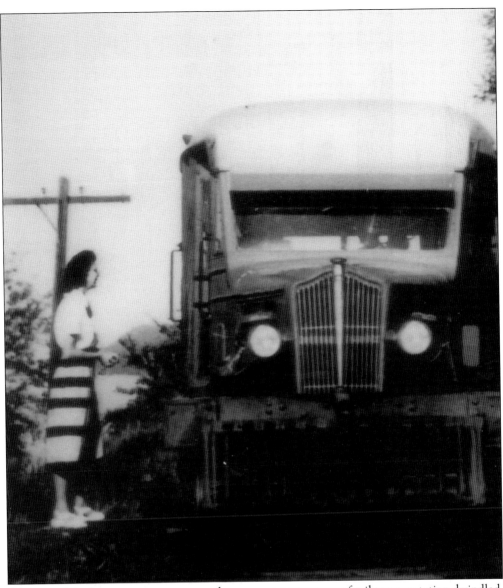

As automobiles became more common, the passenger patronage of rail transportation dwindled. However, some people still depended on trains for transportation, especially during World War II, when gasoline and tires were strictly rationed. Thus, the dinky, created from a bus attached to railroad wheels, was born. It was used to travel along the existing railroad tracks for short distances, such as between the neighboring communities of Alton to Elsah and Grafton to the west along present-day Illinois Route 100, also known as the Great River Road, which is a National Scenic Byway. A railroad company created the dinky, which served multiple communities and carried mail for several years after World War II. Pictured is Godfrey resident and Stanka family descendent Mary Stanka, who is standing at the dinky. This photograph was taken about 200 feet west of the site of the former Riehl's Station, which burned several years before. The second original dinky of only two used to service the Godfrey community and neighboring towns is now in St. Louis's Museum of Transportation, where it is one of the top exhibits at the museum. The museum is located in the same metropolitan area as Godfrey.

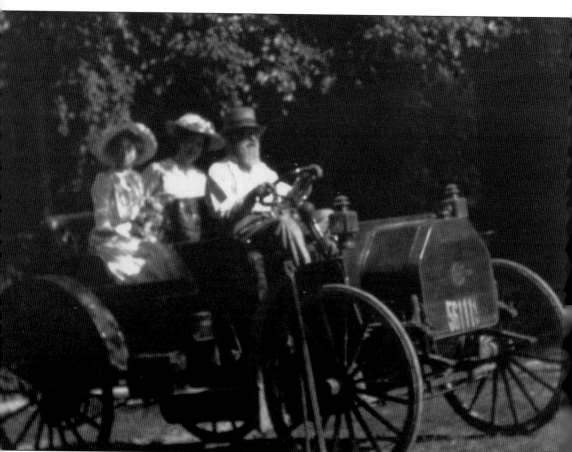

Pictured here is patriarch E.A. Riehl in his International truck. The vehicle had solid rubber tires about two inches wide and two inches thick. It had a two-cylinder engine and a chain drive. Once abandoned by Riehl on his property, the vehicle became a favorite play place for Riehl's grandson Erwin A. Thompson.

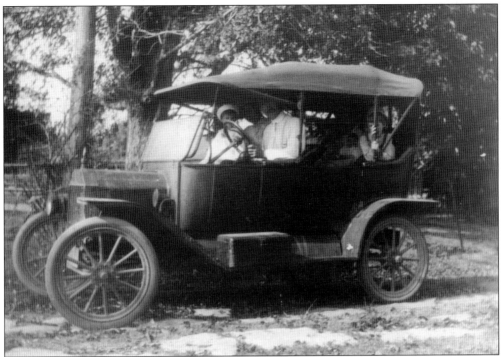

E.A. Riehl, pictured above at the wheel of his Model T Ford, became one of Godfrey's first citizens to acquire an automobile. The image below was taken during the building of E.A. Riehl's son Walter Riehl's house in the present-day 5300 block of Godfrey Road, also known as US 67, near where Clay East Supply is located today. Notice the rear view of E.A. Riehl's International truck to the left and his Model T Ford to the right.

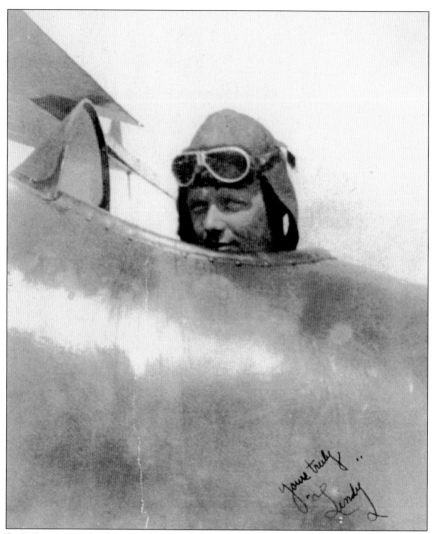

Around 1925, young Charles "Lindy" Lindbergh flew the US mail from St. Louis, Missouri, to Chicago, Illinois. He is pictured smiling from the cockpit of his plane at young Godfrey resident Francis F. Crivello (1916–2012), who took the picture with his 1920 Kodak box camera. Crivello, who was nine years old at the time, had a lifelong fascination with aviation. Francis, his younger brother Eugene, who is 93 and still lives in the Alton-Godfrey region, and older, late brother, William, visited Lindbergh at Robertson Airport, now present-day Lambert-St. Louis International Airport. Crivello's original photograph is displayed in the Missouri Museum of Aviation. Godfrey's third and current mayor Michael J. McCormick received a framed copy of the photograph from the Crivello brothers, which he hung at Godfrey Village Hall in the Mayor's Office. In a book written by asparagus farmer Ben Droste and his wife, Ben recalled Lindbergh standing on the front porch of Droste's childhood home while talking to his father, who lived on the Droste homestead on present-day Airport Road, about a place to have an emergency landing field and beacon light along the US mail route that he piloted. The US government subsequently leased part of William L. Waters' farm, located at the north end of present-day Airport Road where now a Walmart Supercenter sits, on the same road in Godfrey as the flying field, where a tall, steel tower topped by a bright, rotating beacon light was erected. Lindbergh landed in Godfrey several times, mostly due to inclement weather. (Courtesy of Michael J. McCormick)

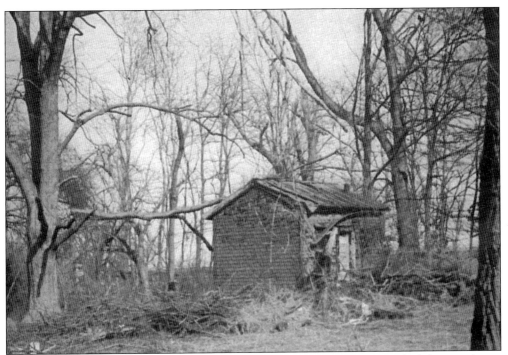

Pictured is the small, green building, about 6 feet by 12 feet, used as a storage shed that stood near the tower. Each airmail pilot had a key to the shed and sometimes used it as an overnight bunker. The building housed several five-gallon cans of gas, some motor oil, and a telephone. Electric location lights outlined the landing strip to aid pilots during emergency nighttime landings. At that time, a beacon light was located in Missouri at St. Louis and St. Charles, and in Illinois at Godfrey, Medora, and on up the line to Chicago. Lindbergh later flew his Ryan airplane, the *Spirit of St. Louis*, in the first successful transatlantic flight, which opened the era of modern aviation. Lindbergh became known as an aviation genius. (Courtesy of Michael J. McCormick)

This image shows an artist's rendering of a monument to the aviation genius, although it never came to fruition. However, with the help of local volunteers, the original storage shed was renovated around 2001 and now stands near Godfrey's Village Hall municipal building on Godfrey Road (US 67). (Courtesy of Michael J. McCormick)

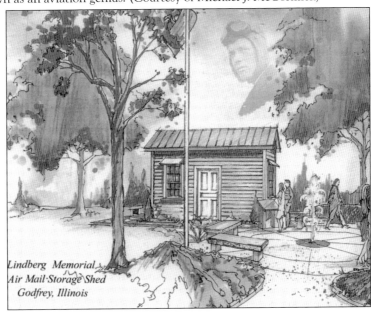

Lindberg Memorial Air Mail Storage Shed Godfrey, Illinois

The McAdams Scenic Parkway is but one segment of the Great River Road that runs from Godfrey's neighboring city of Alton, through Godfrey along the Mississippi River, to the city of Grafton to the west. Godfrey contains the longest stretch of the National Scenic Byway from Alton to Eldred, Illinois. The entire stretch of highway is also known as Illinois Route 100. Planners originally envisioned the Great River Road following the Mississippi River from its beginnings in Minnesota to the mouth of the Gulf of Mexico. The McAdams portion of the highway provides stunning scenery.

Five

COMMUNITY AND SOCIAL LIFE

E.A. Riehl's wife and family matriarch Mathilda Roesch Riehl, who died in 1910, moved from her native Germany to the United States when she was seven years old. Her mother and younger sister died of cholera during the family's trip across the Atlantic Ocean, where they contracted the illness, died, and were buried at sea. Mathilda, seen here, never learned to speak fluent English. She spoke German in conversations at home with her children. Erwin A. Thompson, who is the grandson of E.A. and Mathilda Riehl, came to live with his by-then widowed grandfather when Thompson was nine months old due to having pneumonia and his parents being unable to take care of him.

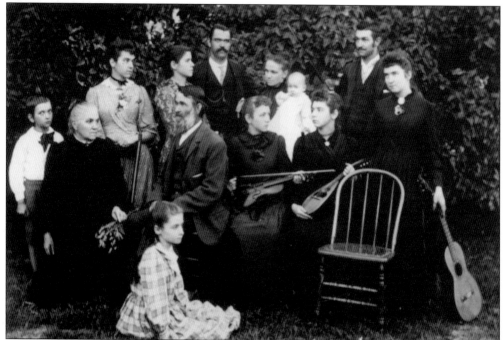

Thompson, who is a well-known regional musician and teacher of old traditional songs, acquired his love of music and stringed instruments from the Riehl family. Shown here is Thompson's mother, Anna, as a young girl sitting on the lawn, and Riehl family members. From left to right in the first row are Thompson's grandmother Mathilda; grandfather E.A. Riehl; and the Riehls' daughters Amelia, holding a violin, and Emma, holding a mandolin. In the second row are, from left to right, the Riehls' daughters Julia and Alice; the Riehl's son Frank; Frank's wife, Jessie, holding their daughter Irene; and the Riehl's son Ed. Riehl's daughter Helen is holding a guitar at the far right. Both Thompson's aunt Amelia and uncle Ed played violin; his aunts Julia and Helen played guitar. His aunt Emma played mandolin and his aunt Alice played piano. The boy at the far left is unidentified.

Longtime Godfrey resident Erwin A. Thompson's family of mostly aunts and uncles are pictured on the Riehls' croquet grounds at his ancestral homestead in Godfrey built by his grandfather and family patriarch E.A. Riehl. Thompson's late wife, Ruth Evelyn Johnston Riehl, late daughter Julia Thompson, and son Gary Thompson, of Bloomington, Illinois, all knew the Riehls' daughters Emma and Amelia Riehl during the women's later years. Thus, Thompson and his family agreed that the two women in white, third and fourth place from the left, are his mother, Anna, and aunt Amelia.

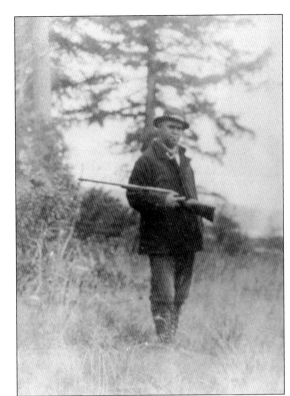

E.A. Riehl's sons Frank (at right),
and Walter Riehl (below) each loved
to hunt. Frank is shown with his
gun on the Riehl homestead, which
became known as Evergreen Heights.
Walter, with his gun, is holding a
string of unidentified game. Walter
liked to duck and snipe hunt on
the Mississippi River's sandbars.

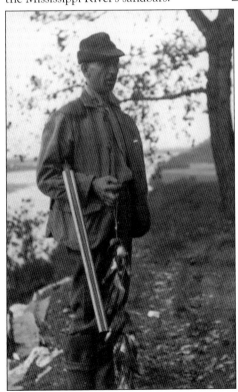

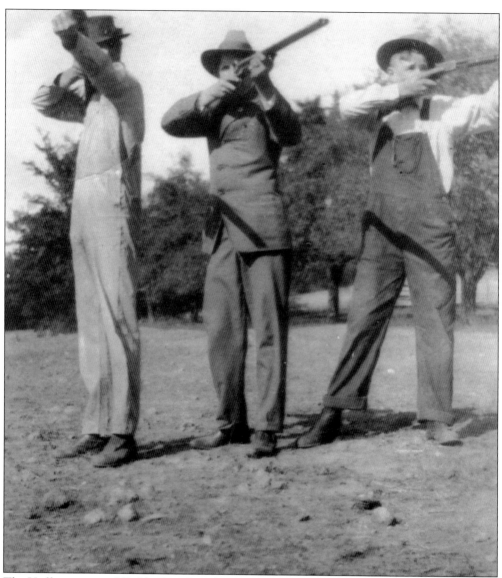

The Hoffmans, one of Godfrey's earliest families, hosted trap shoots, which were done with clay pigeons, or, as participants called them, "blue rocks." Pictured here are competitors in this sport. The winner's prize often included a family's holiday goose or turkey. Competitors gathered and decided who would shoot within their group. The group members each put in a certain amount of money, enough to cover the goose or turkey and then some. The firing line was a certain distance from where the targets were thrown. Targets were thrown from a piece of machinery that was operated from back at the firing line. The machine firing the target was housed in a small dugout that was well covered with dirt so that there was no danger of being hit when someone was in the dugout. When the man firing within a competing group was ready he would say, "Pull!" The machinery operator would pull a lever and a blue rock would sail out and the marksman would fire at it. The neighborhood gathered for these affairs, as well as men from around the country who would come to try their skill and meet other marksmen. The men did the shooting; the women fed the men. Sometimes, a group would sell edibles, such as hot dogs, for a small charge to cover the expenses. (Courtesy of Verna Hoffman.)

This September 1919 photograph shows Emma Riehl Gibbens with her husband George Gibbens of Pike County, Illinois, on their wedding day. The photograph below, taken by the US Department of Agriculture on April 9, 1923, is of George Gibbens standing by the Boone chestnut tree, which is the photograph's main subject. This was at the peak of Riehl's chestnut production. Boone was a variety that came from Riehl's work of cross-pollinating the American chestnut with the Italian chestnut—an idea that he got when he went to college in the eastern United States. The photograph was shot in the location that the Riehls referred to as the Quince Orchard, where Riehl worked on projects to find a marketable fruit. The small evergreens were planted by Riehl in the second ravine from the main house. The first pine hollow on the property was mostly spruce; the second hollow was of white pine. The ground between the evergreens was cleaned up by hand.

Pictured at left is Ed Riehl. This photograph was taken at college in Valparaiso, Indiana, where his father, E.A. Riehl, sent him to learn more and better things to do in the world of agriculture. But Ed spent his time learning music, which did not please the no-nonsense and practical Riehl patriarch. Thompson recalled that his aunts told him their father told Ed to come home; Ed told the family that he came home to "save the farm." The photograph below shows Ed Riehl in later years at his own farm.

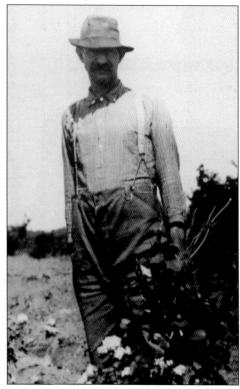

E.A. Riehl's sister Lena Riehl Humphrey, a 1907 graduate of Monticello Female Seminary, returned to Godfrey to celebrate the 50th anniversary of her graduation. She is pictured here on the day of the 50th anniversary, modeling the same clothes that she wore at her Monticello graduation ceremony. Now, the former seminary campus belongs to Lewis and Clark Community College on Godfrey Road (US 67).

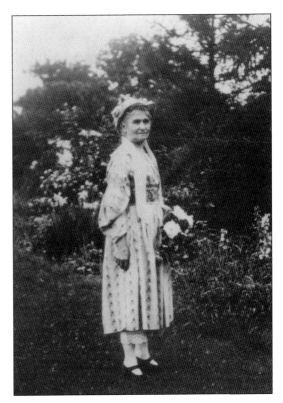

Emma Riehl is shown here modeling a dress worn by her younger sister Amelia to St. Louis's prestigious Veiled Prophet Ball years prior. She modeled the dress on the front porch of the Riehl main house. She was approximately 70 years old at the time.

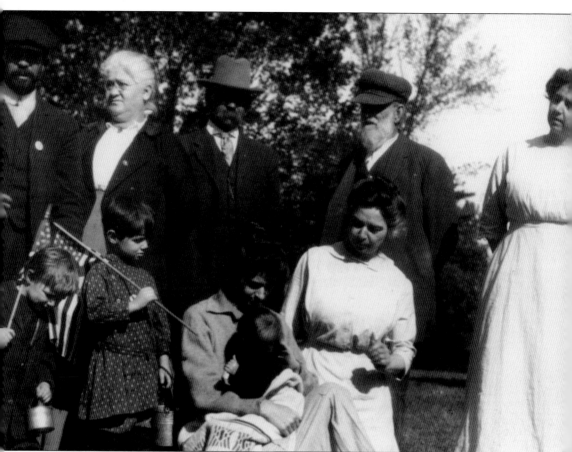

This photograph was taken on the Riehl homestead's front lawn in the fall of 1913, before Erwin A. Thompson was born in 1915 to E.A. Riehl's daughter Anna. The photograph portrays Thompson's parents, J. Arthur and Anna, after they returned with their immediate family from their 6.5 years as missionaries in Korea, where they supervised, among several other things, the building of the country's first girls' school. The Korean peace treaty was signed, which ended the Korean War on July 27, 1953, in that building. Shown in the front row from left to right are Thompson's older brothers, Willard and Ralph, holding American flags that were given to them when they arrived on US soil upon their return trip; Thompson's mother, holding his older sister Eleanor; and Thompson's aunt Emma Riehl; (second row) Thompson's father, J. Arthur Thompson; Erwin's paternal grandmother, Margaret Jeanette Thompson; Erwin's paternal grandfather, W.J. Thompson; Erwin's maternal grandfather, E.A. Riehl; and Thompson's aunt Julia Riehl.

Erwin A. Thompson's uncle George Gibbens is seen here with Thompson's son Gary on his back. Notice the yew trees in front of the Riehlses' main house and the edge of the barn to the left. Born during the Civil War, Gibbens was in his late 80s when this photograph was taken. Gibbens often helped on the Riehl farm and worked in the homestead's barn with his cattle.

Pictured is a woman fishing from a portion of the bank of Piasa Creek on E.A. Riehl's property; Erwin A. Thompson believes it is his aunt Julia Riehl. The woman is using cane poles, with one in her hand and another propped up on the bank beside her to the left.

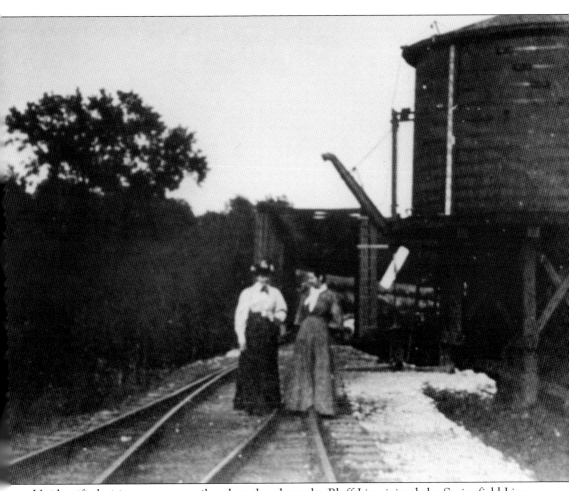

Unidentified visitors pose on railroad tracks where the Bluff Line joined the Springfield Line at the present-day Lockhaven Y. The respective lines had to watch each other's time. The Bluff Line railroad connected neighboring Alton, to the southeast of Godfrey, with a stop at Riehl's Station, to Grafton, which was to the west. The image clearly shows the Y where the two railroads parted. The Bluff Line locomotive went to Alton and the Springfield Line locomotive went to Springfield, Illinois and beyond. The Bluff Line and Springfield Line changed hands many times and once was the Chicago, Peoria & St. Louis Railway. Also shown are the water tank and coal chutes, as well as the bridge across Piasa Creek in the background. The Y was located on what became the grounds of the Lockhaven Golf Club at Lockhaven Road, off the Great River Road, also known as Illinois Route 100. The golf club is across the four-lane highway from Piasa Creek at Piasa Harbor, owned and managed by the Great Rivers Land Trust, which maintains a fishable lake that is open to the public adjacent to Lockhaven Golf Club's golf course. The nonprofit Great Rivers Land Trust saves land from development and is responsible for preserving Godfrey's majestic river bluffs.

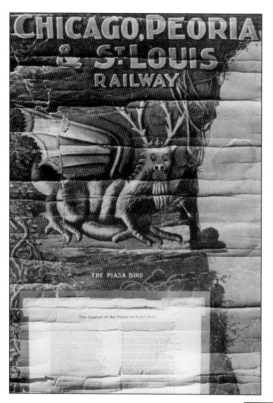

THE PIASA BIRD

The writing in small print on this old Chicago, Peoria & St. Louis Railway calendar is a poem written by E.A. Riehl's son Frank; it was titled "The Legend of the Piasa." The poem is about the legendary Piasa Bird, which is pictured on the calendar above the poem that can be found in Frank's book, *Poems of the Piasa*, published in 1896 in the adjacent town of Alton, Illinois, by Melling and Gaskins Printing. Erwin A. Thompson's daughter, the late Julia Thompson, shown below, was a research scientist and full professor at the University of Pittsburgh in its physics and astronomy department and had the book re-published in Russia, where the original book could survive the reproduction process. Thompson worked as a researcher for years in Novosibirsk, Siberia, on and off from approximately 1988 to the late 1990s; ten years at CERN, a European nuclear research center in Geneva; and ten years at the Brookhaven Lab in Long Island, New York. The Thompson family distributed the Russian-made copies of to relatives and interested historians. A very limited number still are available.

A couple staying as guests at the Riehls' homestead in the late 1800s are shown using a stile to cross small streams of water among the fields on the Riehl property, where E.A. Riehl's daughters Emma, Julia, and Amelia operated a lodging establishment during the last part of the 19th century. Stiles were similar to small stepladders that women in particular used to step over small areas where they otherwise would have brushed their long skirts on the ground.

Several structures existed on E.A. Riehl's property, including the White Cottage, which is pictured and preserved today where Riehl's descendants still live. The little "house" to the right in the photograph was a framework of iron strips covered with roses.

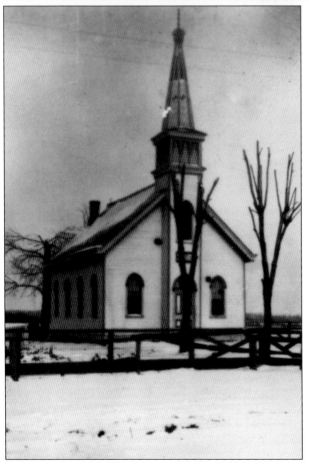

E.A. Riehl and his daughter Emma Riehl Gibbens are seen here visiting the late Riehl matriarch Mathilda Roesch Riehl's grave at the Melville Cemetery, which still exists today in its original location and is the home of E.A. Riehl's family plot. The cemetery is located at the rear of the former property of the Melville Congregational Church site on West Delmar Avenue (Illinois Route 3) near Clifton Terrace Road in Godfrey. Riehl (1833–1925) is buried there along with his wife, their daughters, and Riehl's brothers. Riehl's surviving grandson Erwin A. Thompson's plot lies between his two aunts, Julia Riehl (1871–1940) and Amelia "Mim" Riehl (1877–1954), who together raised Thompson.

Pictured is the former Melville Congregational Church that Erwin A. Thompson's grandfather, E.A. Riehl, helped build. The area was a neighborhood known as Melville; today, a convenience store named Melville Dairy is located east of Melville Cemetery.

The distinct neighborhoods of Melville and Clifton, as it was first known, stood at the present-day intersection of Clifton Terrace Road and West Delmar Avenue, also known as Illinois Route 3. The Melville Post Office, which was also a dry goods and grocery store, is shown. The postmistress is standing in the door. Note the man riding the donkey in front.

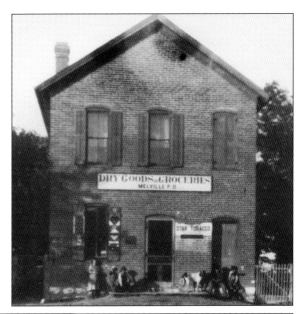

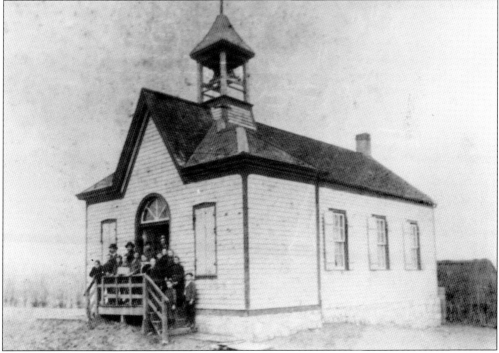

Clifton Terrace Road, which still exists today, ran between the road's intersection near present-day Great River Road (Illinois Route 100) and the road's intersection with present-day West Delmar Avenue (Illinois Route 3) where Godfrey's Melville neighborhood was concentrated. During Clifton Hill School's era (shown here), Godfrey residents referred to present-day West Delmar Avenue as the hard road or Grafton Road because it went into Jersey County, where the small riverfront town of Grafton is located west of Godfrey. The Grafton Road became one of Illinois's first roads made of pavement. At one point during the 1920s, Illinois had only five miles of paved roads. This made getting a hard road a big event for Godfrey and its citizens.

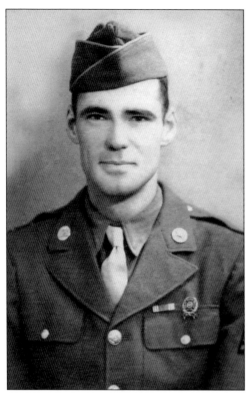

Sgt. Erwin A. Thompson earned a Purple Heart for injuries received from enemy fire near Stohlburg, Germany, in 1943; the Combat Infantry Badge; and a Silver Star for "gallantry beyond the call of duty." He is a combat veteran of World War II. Today, Thompson recalls one of his life's proudest and most poignant moments occurred when one of the men he helped train at Camp Fannin in Texas told Thompson after he had been in combat, "Sergeant, I am alive today because of the things you made me learn."

Thompson's wife, Ruth Evelyn Johnston Thompson, is shown in this picture at approximately 40 years old. Before she married Thompson, Ruth was a teacher who began her career in a one-room schoolhouse. Later, she taught for three years at the Godfrey School. Godfrey High was located upstairs in the same building as Godfrey School, before Godfrey joined the Alton School District, where Ruth taught after she was married. The Thompsons had three children: the late Julia Thompson, a research scientist and university professor; Gary Thompson, of Bloomington, Illinois, who is a retired high school teacher; and Janet Riehl, an award-winning author, poet, and artist, who lives in St. Louis, Missouri. Both Gary and Janet spend time at their childhood home of Evergreen Heights.

Erwin A. Thompson is seen here playing a beloved fiddle. Thompson, born November 9, 1915, in Schuyler County, Illinois, is a poet, novelist, musician, noted folk artist, and hoe-down square-dance caller. Thompson has been writing poetry, family history, music, and lyrics to original songs for 75 years. He furnished music for local square dances, the national meeting of the Kaiser-Fraiser Club at St. Louis's Museum of Transportation, the reenactment of the Lincoln–Douglass debate in Alton, and other regional events. He was named a folk treasure by Arts Across Illinois and was featured on its television broadcast and website. The letters that Thompson documented for his mother and father and extended family network are archived at the University of Illinois and illuminate the living history of the early 1900s. In 2013, three books of multiple fiction narratives written by Thompson were published; some of the stories were written while he was stationed overseas in World War II and some while he was a Union Electric gas pipefitter and union steward.

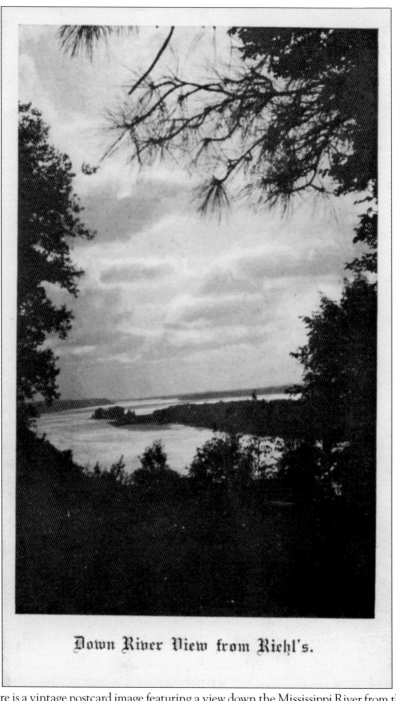

Down River View from Riehl's.

Shown here is a vintage postcard image featuring a view down the Mississippi River from the Riehls' front porch around the mid-1890s. E.A. Riehl's daughter Amelia Riehl took this picture with her 120 box camera; she told her nephew Erwin A. Thompson that she included the evergreen branch on purpose to give the perspective of distance. She became Thompson's closest caregiver after Thompson became ill at nine months old and came to live at the Riehl family homestead.

Six

CONSERVATION
AND MODERNIZATION

Original Godfrey settler John Gottlieb Stiritz, a German immigrant, brought honored traditions from Germany to the Midwest around 1850 when he settled in present-day Clifton Terrace, then known as Cliff Town, which was founded by H. Mason and D. Tolman in 1827. Stiritz's cousin Louis Stiritz brought grapevines from Nekar River in Germany and built grape arbors at Clifton Terrace because it reminded him of home. He also built stone terraces from 1852 to 1865 on the site of present-day Clifton Terrace Park. The original terraces extended row upon row to the top of the bluff that still overlooks the park located at the intersection of Clifton Terrace Road and the Great River Road. The Clifton Terrace neighborhood, originally known as Cliff Town, got its name from the land's topography of cliffs and Stiritz's terraces. The village of Godfrey dedicated Clifton Terrace Park on September 1, 1996. The park sits on the same site as Stiritz's business ventures.

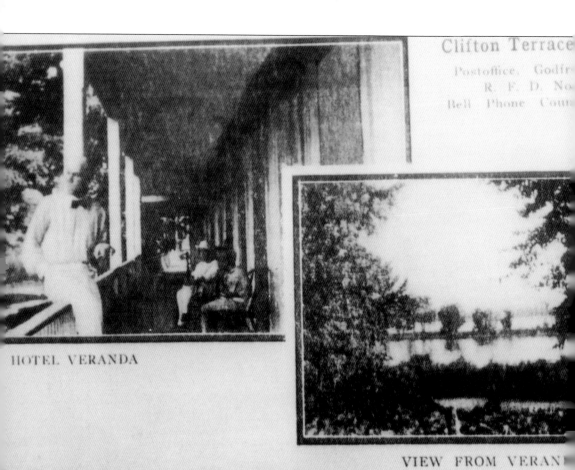

HOTEL VERANDA

VIEW FROM VERAN

Clifton Terrace, located in and around the present-day Clifton Terrace Park, became a distinct neighborhood in Godfrey. In 1874, early Godfrey settler Louis Stiritz and his family members, opened a hotel called Clifton Inn to accommodate the St. Louis Cement & Lime Company, which was a cement plant located on Clifton Terrace Road. In later years, tourists arrived by paddle-wheel boats to enjoy wine, home-cooked meals, and the lush riverfront countryside. In 1895, H.A. Fisher built a competing hotel on the riverfront directly in front of Clifton Inn. This prompted Stiritz to add cottages, a large pavilion, a dance hall, refreshment stands, picnic tables, and benches. According to research done at the time of conversion of Stiritz's familial land to Clifton Terrace Park, Clifton Inn remained quaint while Fisher's establishment was lavish and drew wealthier vacationers. A fire destroyed Fisher's hotel in the early 1900s. Stiritz's three daughters ran Clifton Inn until 1929. It then operated as Clifton Terrace Hotel under Kaye and Mike Whitford, until a fire destroyed the property in 1959. Today, the namesake diner Clifton Inn sits at the intersection of Clifton Terrace Road with West Delmar Avenue (Illinois Route 3).

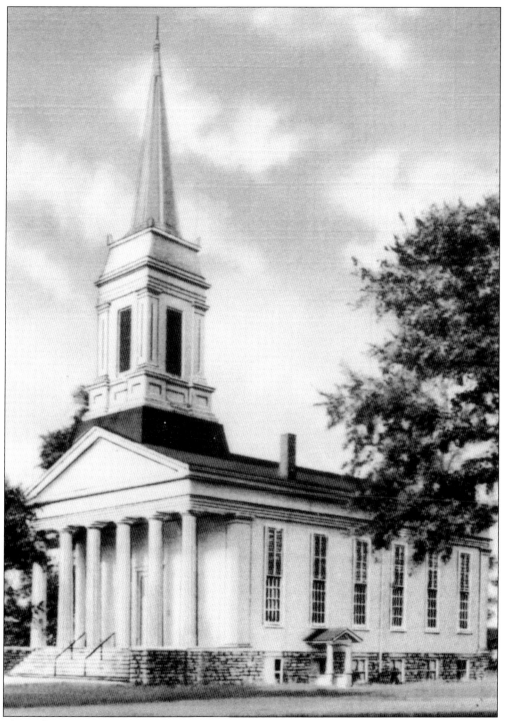

Shown here is an artist's rendering of the Benjamin Godfrey Memorial Chapel on the campus of Lewis and Clark Community College after the college purchased the historic landmark. The New England chapel in the Greek Revival style originally stood on Godfrey Road (US 67), across the street from the former Monticello College campus.

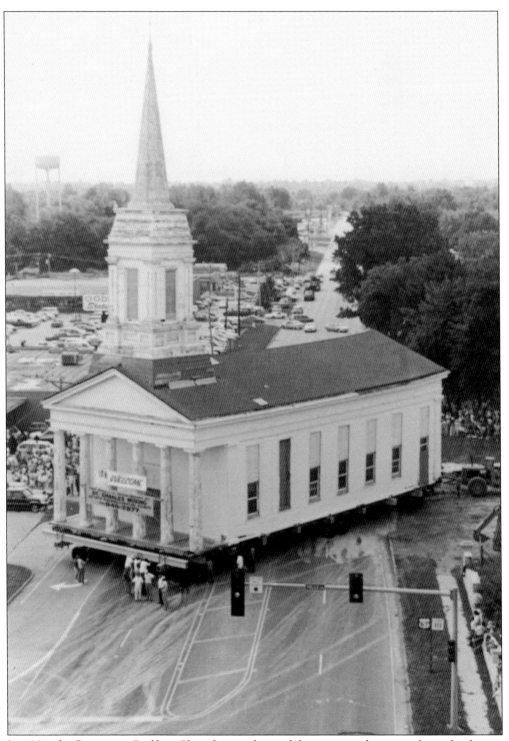

In 1991, the Benjamin Godfrey Chapel was relocated from across the street from the former Monticello College onto the campus of the Lewis and Clark Community College, which purchased the land from Monticello College in 1970.

Lewis and Clark Community College has a number of campus buildings, each designed to complement a remarkable architectural heritage. Its handful of buildings of modern design seamlessly fit into the architectural landscape of the historic designs of the former campus of Monticello Female Seminary, such as buildings designed by German architect Theodore Link, dating to 1889–1890. To this day, the college continues to maintain the historic character of the campus through the harmonious use of the architectural design and details on all new structures.

Pictured is the edifice of Monticello College's Hatheway Hall, which was a gift of Spencer T. and Ann W. Olin to the college. The building had in the center a 1,000-seat theater with balcony seating and access to box seats through a private reception room. Adjoining the theater building on the south side is an Olympic-size swimming pool and on the north side a gymnasium. Originally dedicated on October 18, 1963, as Hatheway Hall, Monticello College's new cultural center was named after Ann Olin's mother, Norah Dell Hatheway Whitney, who graduated from Monticello Female Seminary in 1889. She stood by her classmates in June of that year and helped lay the cornerstone of Caldwell Hall, the foundation of the new Monticello Female Seminary, after the school had burned in 1888. Hatheway Hall is known for its unique architectural design, shown here with classic white columns that were almost Grecian but with modern lines. Renamed Hatheway Cultural Center after it underwent renovation and remodeling, the building was officially rededicated on October 18, 2011. The venue hosts thousands of visitors every year for concerts, plays, and numerous other college and community events and art exhibits.

Erickson Residence Hall, the last building erected on the Monticello College campus (1967) was named for Martina Erickson, Monticello Female Seminary president from 1910 to 1917. Although modern in design, it was kept in line with Monticello's tradition of using white limestone. Today, it houses the administrative offices of Lewis and Clark Community College.

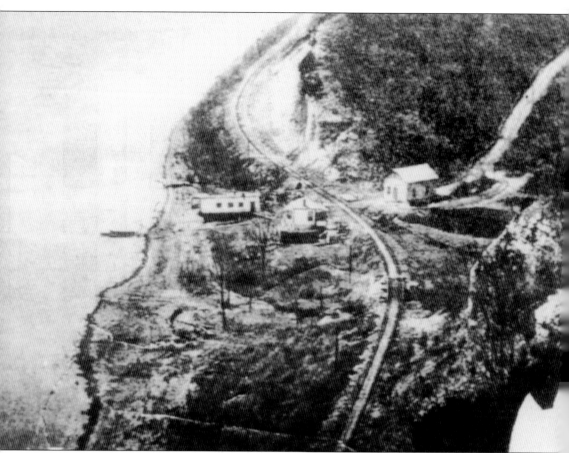

In 1944, the Great River Road (Illinois Route 100) was completed extending from Alton, which neighbored Godfrey to the southeast, to Riehl Landing, which was one mile upstream from the Clifton Terrace neighborhood. Riehl Landing, pictured at its approximate former site, was located at the present-day intersection of Stanka Lane and the Great River Road.

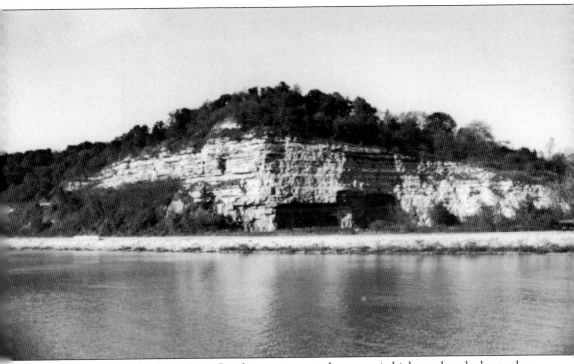

In 1966, the rest of the Great River Road was constructed as a scenic highway, largely due to the inspiration of John D. McAdams, and was dedicated and originally named McAdams Highway in honor of McAdams family. McAdams (1875–1941) was the son of a famous archeologist, William McAdams Jr., who first explored burial mounds and petroglyphs along the Mississippi River bluffs. Later known as the McAdams Scenic Parkway, it became part of the Meeting of the Great Rivers National Scenic Byway, locally known as the Great River Road, from Godfrey's neighboring community of Alton, to the southeast, to Eldred, Illinois, in 1998. The entire highway is Illinois Route 100.

Early Godfrey settler and patriarch Charles Norman Sr. had multiple business ventures, including Norman's Quarry. The former site location is pictured above to the right, where it looks as though the trees are carved out, leaving exposed limestone rock. It is located on the Mississippi riverfront, just east of present-day Clifton Terrace Park, where stone was obtained from the quarry used to build the McAdams Highway portion of Great River Road, between Godfrey's neighboring community of Alton, to the southeast, and Grafton, to the west. The location of Norman's Quarry was Norman's Landing, as locals today refer to the site of Norman's business ventures. Norman purchased the familial land in 1904, where the family began harvesting mussels to sell to an Alton button factory. Later, the family built wooden barges and towboats that they used to transport apples from Calhoun County, Illinois, to an Alton vinegar company. The family later expanded the riverfront business to include sand dredging, marine transportation, and even the servicing of passing towboats. The Great Rivers Land Trust has its offices at Norman's Landing, which is just east of Clifton Terrace Park. The Great Rivers Land Trust's address is 2102 McAdams Parkway.

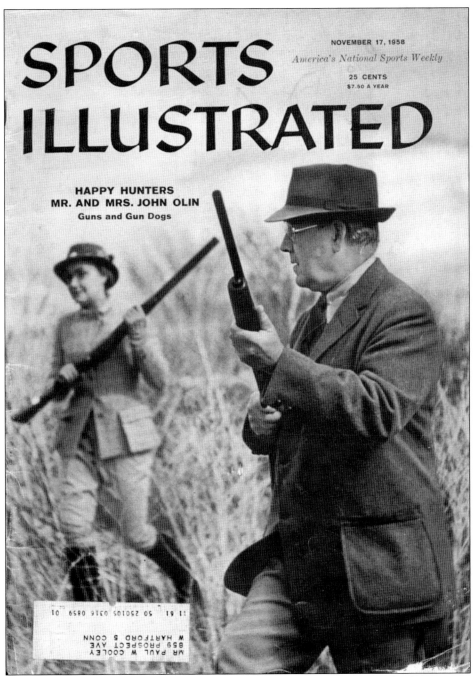

Surrounding Norman's Landing is the 300-acre John T. Olin Preserve and other properties protected by the Great Rivers Land Trust; the lands are managed by The Nature Institute. The Olin Preserve, located on The Nature Institute's grounds, was donated by the Olin family. The Nature Institute manages the John T. Olin Nature Preserve and neighboring properties for a total of 415 acres of managed lands. This 1958 Sports Illustrated cover portrays John T. Olin and his wife, Evelyn, skeet shooting; they were both avid enthusiasts of the sport. The Olins' private skeet shooting range previously existed on the land that the couple donated to the institute.

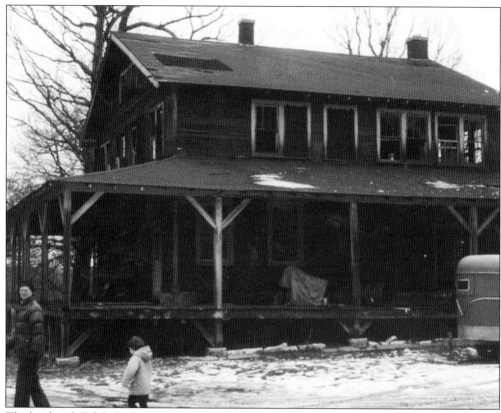

The landmark Talahi Lodge, now owned by The Nature Institute, was built in 1927 for the YWCA of Alton; Mr. and Mrs. Charles Levis gave the campground to the YWCA in 1931. Swimming, sports, and other activities were offered. Girl Scout camps also were held here. Today, the building is a central structure within The Nature Institute's grounds and a learning center for sustainable, organic culture. The image below shows more structures on The Nature Institute's grounds.

The Nature Institute's offices are located in the former home of the late James Nelson (pictured above in front of his home in earlier years) and his late wife, Aune Nelson, whose 46-acre property is part of the institute's 415 acres. The entire grounds of The Nature Institute appear much as the land did 100 years ago. The grounds contain acres of trees and plant species native to Illinois. James Nelson is pictured at right, in later years, wearing a Russian hat that he acquired while visiting the country.

Pictured is the historic former swimming pool once located on The Nature Institute's present-day grounds. The pool was one of the first used for public education in the area; people also visited from miles around to swim in the Olympic-size pool. Swimming lessons were the order of the day for campers at the YWCA of Alton's Camp Talahi in the summer.

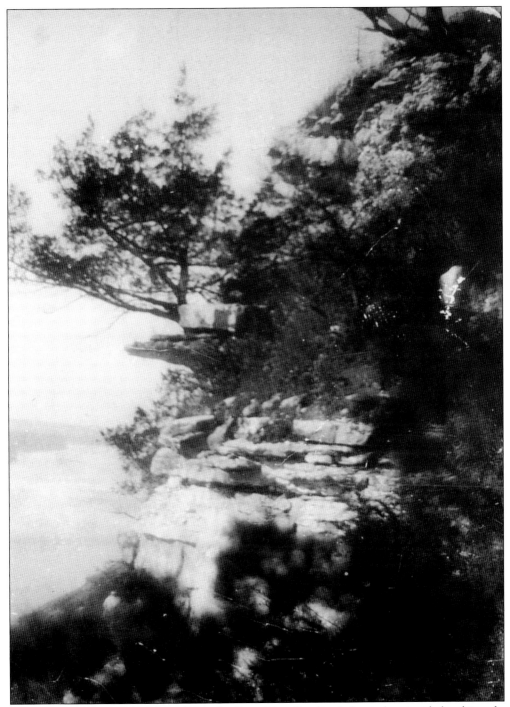

Fossils found in the rock bluffs parallel to the Great River Road include corals, crinoids, brachiopods, bryozoans, cephalopods, and trilobites. At least 230 million years ago, shallow seas and swamps deposited sedimentary layers of limestone. As the seas and swamps receded, the Mississippi River eventually carved through the limestone, creating the Mississippi River Valley with exposed 150-foot-high limestone bluffs.

The Great Rivers Land Trust, led by executive director Alley Ringhausen, has its offices located at Norman's Landing, just east of Clifton Terrace Park. The conservation organization protected Godfrey's riverfront for the purpose of preserving the Mississippi River landscape in perpetuity for people to see it as Godfrey's earliest settlers saw it. The Great Rivers Land Trust (GRLT) is a nonprofit organization dedicated to the preservation and enhancement of natural resources in the entire St. Louis Metropolitan Region. The GRLT protects more than 3,000 acres of open space and wildlife habitat through ownership or conservation easements. The Mississippi, the Illinois, and the Missouri—America's great rivers—meet in a broad floodplain bordered by majestic 150-foot-tall limestone bluffs that tower above the Great River Road. The GRLT is operated by a 13-member board of directors and numerous staff members.

The GRLT was formed in 1992 to protect the lands along the Meeting of the Great Rivers National Scenic Byway, locally known as the Great River Road. The Great River Road traverses 15 miles total between the Mississippi River and the bluffs from Alton, to Grafton, to Godfrey, which contains the most miles of the Great River Road. The grounds at the top of the bluff are the home of the La Vista Ecological Learning Center and the Oblate Novitiate. While this space primarily functions to form priests and brothers of the future of the order, it is also home to the Oblate Ecological Initiative. Since 1950, La Vista has been the site of worldwide Missionary Oblates of Mary Immaculate, which is a missionary religious congregation made up of priests and brothers in the Catholic Church. The scenic grounds in Godfrey provide a space of natural beauty and spiritual quiet to reflect on one's appreciation and understanding of "creation's integrity."

Inhabitants have been at the confluence of the Missouri, Mississippi, and Illinois Rivers for thousands of years; French explorers paddled the Mississippi River more than 300 years ago. The American bald eagle makes the Mississippi River bluffs their winter home. In the 25-mile expanse of the broad floodplain, the Meeting of the Great Rivers Scenic Byway allows residents and visitors access to Godfrey's Mississippi riverfront, which has sweeping prairies, lush wooded valleys, and towering bluffs that drew settlers in the early 1800s.

The village of Godfrey became incorporated in 1991 and Lars Hoffman, as president of a village board of trustees, became the first mayor of Godfrey. Hoffman, who died in 2005, had a vision for the primarily agricultural and bedroom community to gain more municipal presence in county government and more access to the benefits of being incorporated, such as grants, infrastructure, roadways, and economic development. Hoffman Gardens at Great Rivers Park, located at the former site of Norman's Landing, represents a memorial to Godfrey's first mayor. The village of Godfrey dedicated Hoffman Gardens in 2007; Hoffman Gardens are so named in honor of Hoffman and his wife, Judy Hoffman, who is a noted historian of Godfrey and wrote *God's Portion: Godfrey, Illinois 1817–1865*.

"Take a look around. It's clean. It's safe. It's unspoile It's everything a family cou want--small town feel with 'big city' opportunities."
-- **Mayor Mike Campi**

I love this village. I've lived here my entire life and farmed the land of Godfrey. I married and raised a family here. And, for past 10 years, I've represented my community and my neighl first as a Village Trustee and then as Mayor.

The second mayor of Godfrey, Michael J. Campion, served on the Godfrey Village Board of Trustees under Lars Hoffman and was a protégé of Hoffman's. Campion followed Hoffman as Godfrey's mayor and served three terms (12 years) in the position. He was a strong supporter of Hoffman's vision for the village and worked to carry out projects that Hoffman started as well as his own vision. Campion came up with the idea of Hoffman Gardens and told Hoffman about the concept while he was still alive; Hoffman knew that his wife, Judy, would be included on the memorial.

The third mayor, Michael J. McCormick, served on the Godfrey Village Board of Trustees under second mayor Michael J. Campion. McCormick is currently serving his second term as mayor. Under McCormick's leadership, Godfrey established a business district and a tax-increment financing district in 2012 to attract more economic development. The districts are a first in Godfrey's history.

DISCOVER THOUSANDS OF LOCAL HISTORY BOOKS FEATURING MILLIONS OF VINTAGE IMAGES

Arcadia Publishing, the leading local history publisher in the United States, is committed to making history accessible and meaningful through publishing books that celebrate and preserve the heritage of America's people and places.

Find more books like this at
www.arcadiapublishing.com

Search for your hometown history, your old stomping grounds, and even your favorite sports team.

Consistent with our mission to preserve history on a local level, this book was printed in South Carolina on American-made paper and manufactured entirely in the United States. Products carrying the accredited Forest Stewardship Council (FSC) label are printed on 100 percent FSC-certified paper.

MADE IN THE